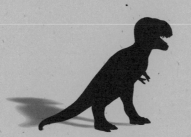

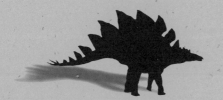

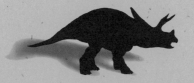

Dinosaurs *of* Distinction

DINOMITE DAYS

PITTSBURGH

A Carnegie Museum of Natural History publication

WRITTEN BY Heather Austin and Matt Phillips

DESIGNED BY Kolbrener, Inc.

PHOTOGRAPHY BY Alexander Denmarsh

ARCHIVAL PHOTOGRAPHS COURTESY OF Carnegie Museum of Natural History

PRINTING BY Broudy Printing Inc.

First Edition, 2003

Printed and bound in the United States of America

Copyright © 2003 by Carnegie Museum of Natural History

Visit us on the web at http://www.carnegiemuseums.org/cmnh

ISBN 0-8229-4221-6

DINOMITE DAYS℠ CONTENTS

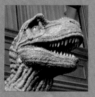

WHY DINOSAURS?

DinoMite Days[SM] is the culmination of a century celebrating Pittsburgh's historical connection to dinosaurs and world-class scientific research. Dinosaurs are ideal subjects for this Pittsburgh-based art event because of the leading international role that our city and its scientists play in documenting the history of life on earth.

At the end of the 19th century, when dinosaur fossils first surfaced in the western United States, a newspaper cartoon showing one of these creatures peeping into the 12th story of a New York skyscraper captivated steel magnate Andrew Carnegie. He dispatched a crew of paleontologists from Carnegie Museum to Wyoming, where, on July 4, 1899, they discovered a bone belonging to a new species of dinosaur later named *Diplodocus carnegii* in Carnegie's honor. This dinosaur would be embraced by the public and affectionately dubbed "Dippy."

Dippy's discovery sparked a golden age of research with scientists from Carnegie Museum of Natural History (CMNH) at the forefront. These scientists found a treasure trove of dinosaur fossils at the Carnegie Quarry in Utah, now part of Dinosaur National Monument. The discoveries included *Apatosaurus, Stegosaurus, Allosaurus,* and *Camarasaurus,* which now populate CMNH's Dinosaur Hall.

Soon after, Pittsburgh steel workers pioneered techniques for mounting incredibly heavy fossilized bones. Andrew Carnegie later provided reproductions of Dippy for museums in Paris, London, Berlin, Madrid, St. Petersburg, Mexico City, Buenos Aires, and other cities abroad, making it the most frequently seen dinosaur in all the world!

Bill DeWalt, *Director*
CARNEGIE MUSEUM OF NATURAL HISTORY
June 2003

Carnegie Museum of Natural History conducts scientific inquiry that creates knowledge and promotes

stewardship of Earth and its life; builds strategic collections to preserve evidence of that knowledge; and

engages the public in the excitement of scientific discovery about the evolutionary, environmental, and

cultural processes that shape the diversity of the world and its inhabitants.

**Carnegie Museum
of Natural History**

One of the four Carnegie Museums of Pittsburgh

A C K N O W L E D G M E N T S

Carnegie Museum of Natural History is grateful to all of its friends—the artists, "sponsaurs," and volunteers—throughout Pittsburgh and the surrounding community who embraced DinoMite Days℠ and contributed to its success.

The museum extends a very special and heartfelt thanks to Susie Perelman for generously giving of her time and creativity in voluntarily leading this ambitious project.

Thanks are also extended to Heather Austin, whose tireless commitment and enthusiasm contributed greatly to the success of DinoMite Days and inspired staff and volunteers alike.

And to all those Carnegie Museum of Natural History staff members who contributed their time and talents to DinoMite Days, thank you.

Finally, and most especially, the museum wishes to thank The Laurel Foundation for its leadership, community-minded vision, and generosity, without which this dream project would not have been realized. To its benefactor, board, and staff, we extend our most sincere thanks—you are all DinoMite!

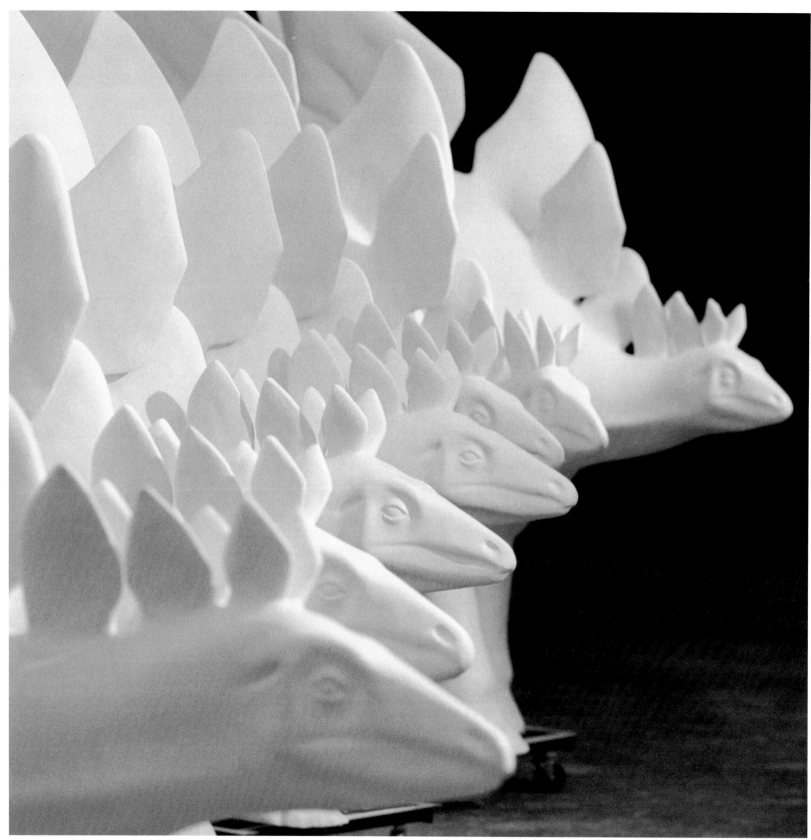

It has been 65 million years since a dinosaur was last seen in the Pittsburgh area. All that changed in the summer of 2003! Carnegie Museum of Natural History created DinoMite Days, a region-wide public art event that turned back the clock to the age of dinosaurs. The exhibit, and the book that tells its story, celebrate Pittsburgh's international reputation for scientific innovation by drawing attention to the world-class dinosaur collection housed at Carnegie Museum of Natural History.

Dinosaurs of Distinction uses hundreds of full-color photographs to illustrate the very creative path the 100 DinoMite Days dinosaurs followed as they made their way through the streets of the Pittsburgh region and into the hearts of its residents. Modeled after the immensely popular "Cow Parades" of Chicago and New York, the Pittsburgh exhibit featured three different species of fiberglass dinosaurs: *Tyrannosaurus rex*, *Stegosaurus*, and *Torosaurus*.

The project has touched the lives of everyone in the region, in one way or another. Businesses and organizations have sponsored dinosaurs. The dinosaurs have ignited the imaginations of emerging and established artists, both local and national, who have decorated and sculpted the creatures. Millions of passersby have delighted in the designs, which have been strategically placed in prominent locations throughout the region.

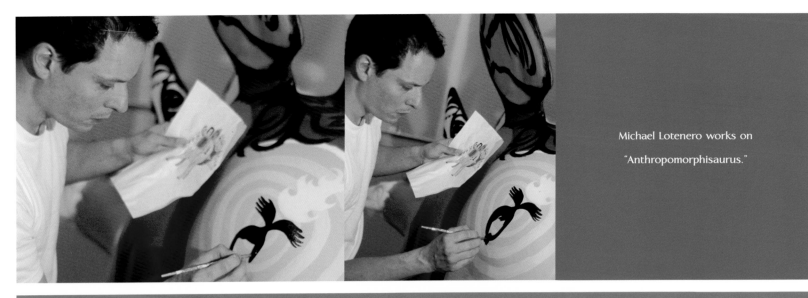

Michael Lotenero works on "Anthropomorphisaurus."

Creating
the Dinos of DinoMite Days℠

Dave Klug's "T. rex V.P." prepares to conquer the world...of business!

Rick Bach welds "Nino the Crusher," his *Torosaurus*-within-a-*Torosaurus* sculpture.

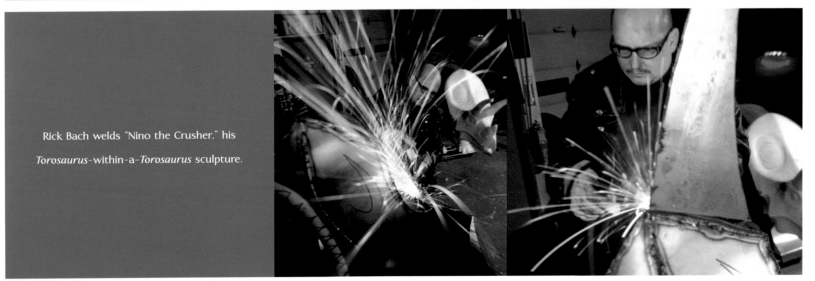

Cynthia Cooley paints a beloved Pittsburgh neighborhood on her dinosaur, "Troyus Hillosaurus."

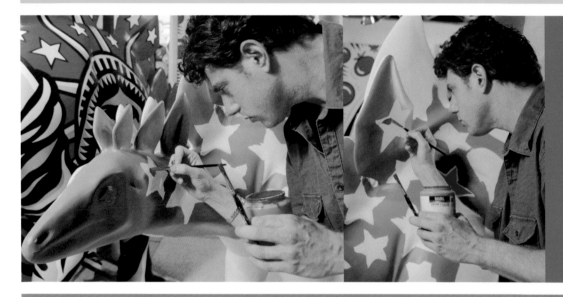

World-renowned artist Burton Morris adds his pop art touch to "I Want You," one of three dinosaurs he created for DinoMite Days℠.

"Seymour Sparklesaurus (a.k.a Sparky)" had his name spelled in Braille on his back by the students at the Western Pennsylvania School for Blind Children.

Students from the National Arts Honor Society at Shaler Area High School covered "Ticket-Saurus: Pittsburgh's Ticket to Culture" with ticket stubs from the region's many cultural events.

John Peter Glover used the vibrant colors of tropical poisonous frogs as inspiration for "Spectrasaurus."

John Alexander inspects his finished work of art, "Pittsburghius Architectaurus."

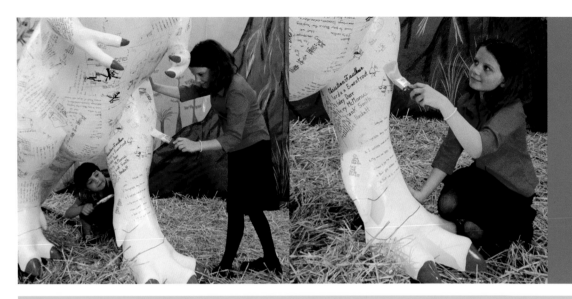

O'Hara Elementary School student Madeline Docimo helps her contest-winning design "Elementarysaurus" come to life.

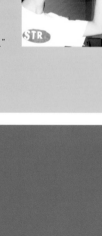

Jason Gotsch puts the finishing touches on the choppers of "Lunasaurus Lux."

Vintage newspapers were among the items Chris Smith collaged to chronicle Pittsburgh history via his "Historapod."

Tyrannosaurus REX

Tyrannosaurus rex is probably the most recognized dinosaur in the world. Although 65 million years have passed since extinction issued its death sentence, this beast continues to captivate dinosaur enthusiasts from preschoolers to paleontologists. 🦖 Following its discovery in the American West more than a century ago, *Tyrannosaurus rex* assumed the crown of predatory king of the dinosaurs. An adult *Tyrannosaurus* was longer than a Port Authority bus and as heavy as a Duquesne Incline car! 🦖 Ranging from the nightmarish to the laughable, the dinosaur's physical features cast *Tyrannosaurus rex* as the consummate carnivore. Its more-than-five-foot-long skull sprouted a mouthful of deadly seven-inch-long teeth. The edges of these teeth were serrated for cutting meat; the only modern creatures with similar dental cutlery are sharks and Komodo dragons. The absurd, seemingly puny forelimbs couldn't even reach the dinosaur's mouth, but could lift several hundred pounds. The dinosaur's most lethal weapons were its powerful jaws, which could deliver a bone-crushing bite. 🦖 Relatives of *Tyrannosaurus rex* were most likely the lightly built dinosaurs that gave rise to the pigeons in Market Square, the birds at the National Aviary, and others of their ilk.

DINOSURGEON

ARTIST: University of Pittsburgh
Medical Center Design Team
SPONSAUR: University of Pittsburgh
Medical Center

Medicine is a natural theme for University
of Pittsburgh Medical Center to employ
in Carnegie Museum of Natural History's
DinoMite Days project. A dose of art,
science, and whimsy is the prescription
for a dynamic design. Clad in blue scrubs,
this fearsome physician makes his rounds
with a giant stethoscope and an x-ray of
a prehistoric patient. With this doctor on
call, a dyspeptic dinosaur would be back
on its feet in no time!

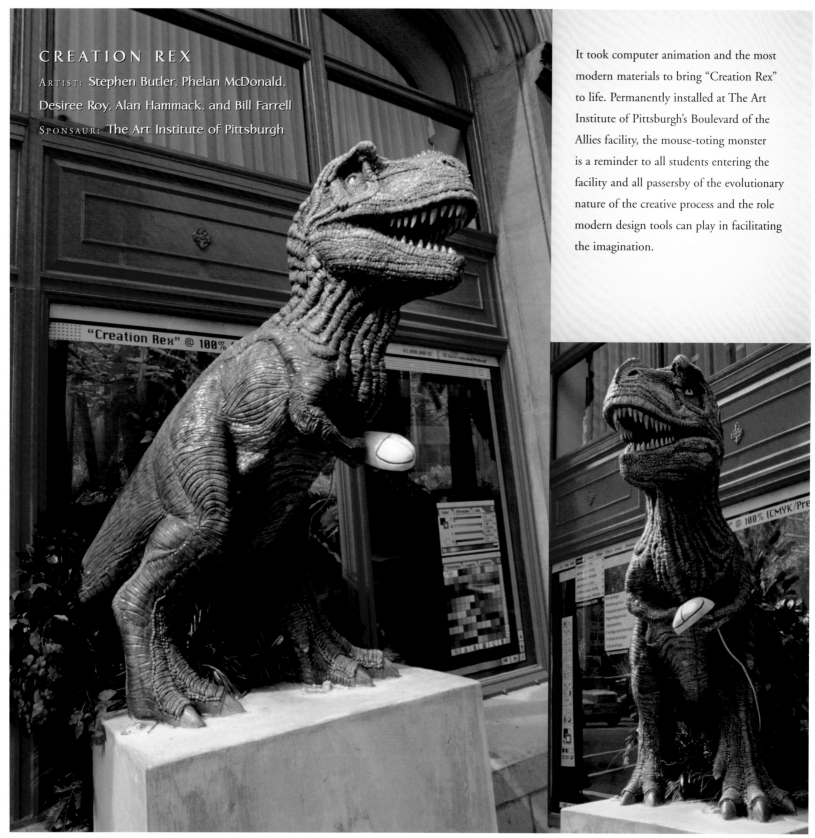

CREATION REX

ARTIST: **Stephen Butler, Phelan McDonald, Desiree Roy, Alan Hammack, and Bill Farrell**

SPONSAUR: **The Art Institute of Pittsburgh**

It took computer animation and the most modern materials to bring "Creation Rex" to life. Permanently installed at The Art Institute of Pittsburgh's Boulevard of the Allies facility, the mouse-toting monster is a reminder to all students entering the facility and all passersby of the evolutionary nature of the creative process and the role modern design tools can play in facilitating the imagination.

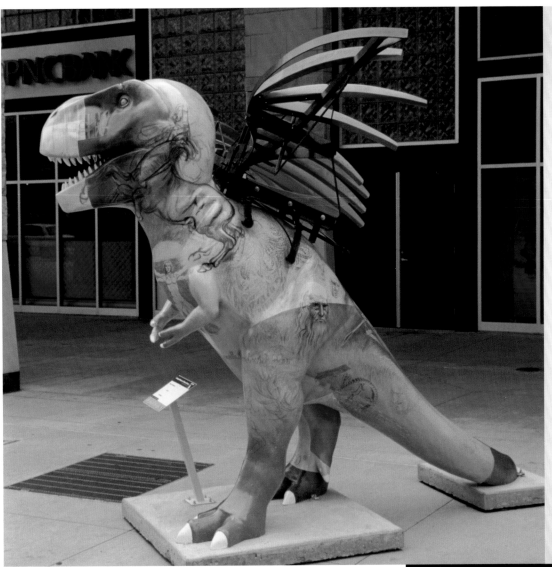

"When once you have tasted flight, you will forever walk the earth with your eyes turned skyward, for there you have been, and there you will always long to return." This sentiment from a poem by Leonardo da Vinci inspired the creative team at Astorino to create a piece of art that inspires hope and stirs the imagination. Steel and wood wings inspired by da Vinci's flying machines rise from its back, while dreamy drawings from his sketchbooks adorn the body.

GENIUSAURUS REX

ARTIST: **James O'Toole and Astorino Design Team**

SPONSAUR: **Astorino**

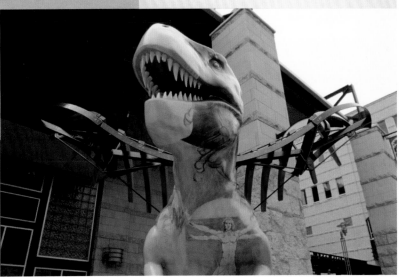

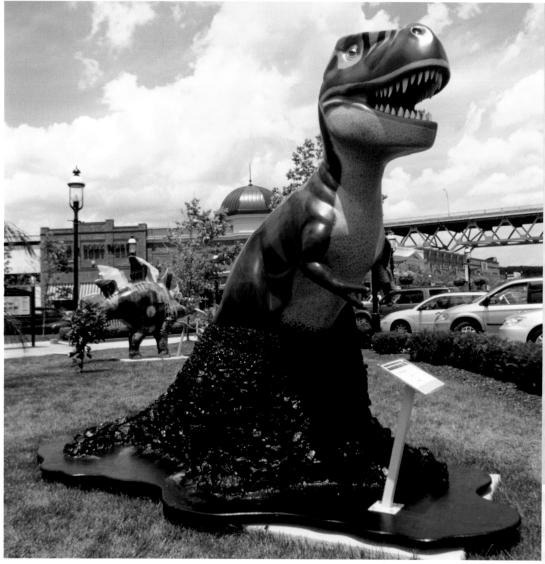

This piece of art raises as many questions as it answers and, ultimately, is completed by the viewer. Is the dinosaur rising from the fuel of the past as Pittsburgh's economy has been reborn out of its coal-, coke-, and steel-based past? Or is the ancient creature dissolving into something even more powerful? Coal dust and large chunks of coal form the bottom of the sculpture.

FOSSIL FUELS

ARTIST: **Patrick Daugherty**

SPONSAUR: **PNC Bank**

DINO FACT

Put a *T. rex* in your tank? Contrary to what many people believe, fossil fuels are not the remains of dead dinosaurs. In fact, fossil fuels were formed from prehistoric plants and animals that lived hundreds of millions of years ago.

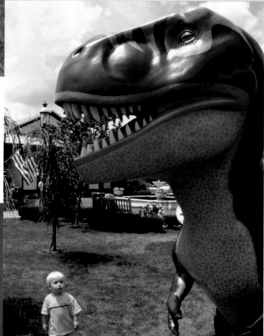

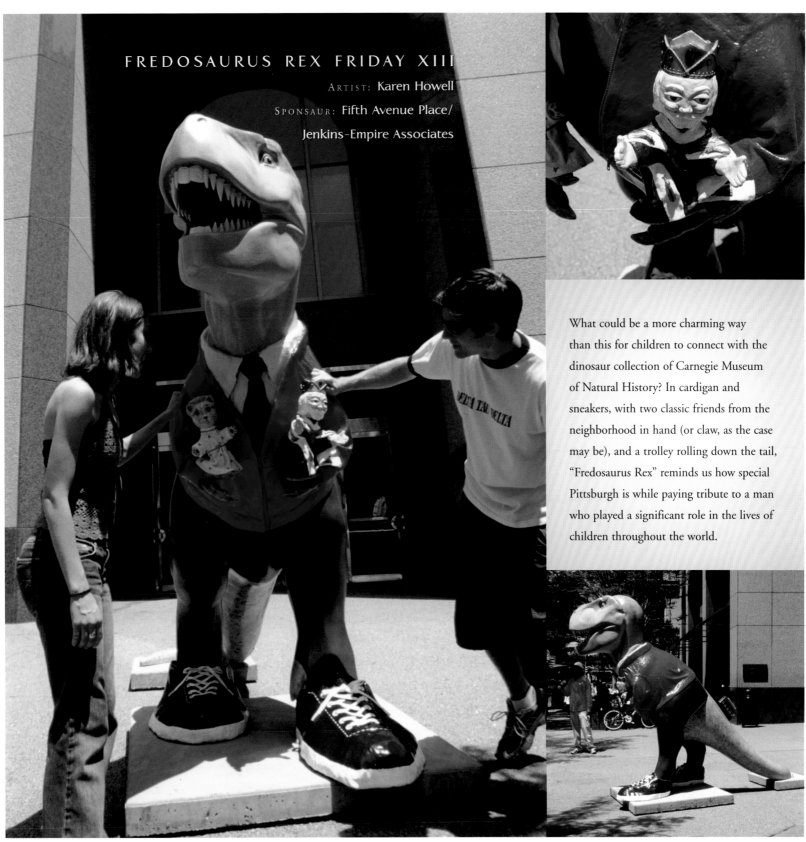

FREDOSAURUS REX FRIDAY XIII

ARTIST: Karen Howell

SPONSOR: Fifth Avenue Place/
Jenkins-Empire Associates

What could be a more charming way than this for children to connect with the dinosaur collection of Carnegie Museum of Natural History? In cardigan and sneakers, with two classic friends from the neighborhood in hand (or claw, as the case may be), and a trolley rolling down the tail, "Fredosaurus Rex" reminds us how special Pittsburgh is while paying tribute to a man who played a significant role in the lives of children throughout the world.

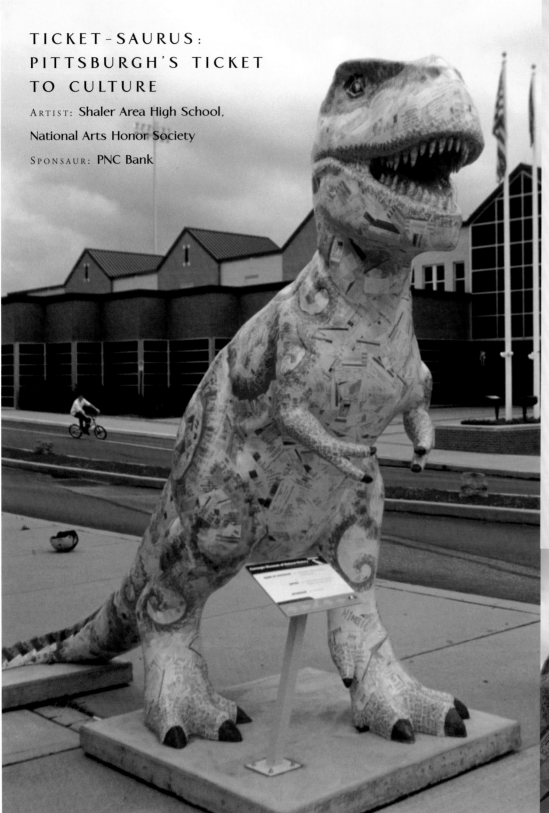

TICKET-SAURUS: PITTSBURGH'S TICKET TO CULTURE

ARTIST: **Shaler Area High School, National Arts Honor Society**

SPONSAUR: **PNC Bank**

Shaler Area High School earned its ticket to DinoMite Days℠ participation through the public schools contest sponsored by Carnegie Museum of Natural History. One of only three dinosaurs donated to winning schools, "Ticket-saurus" was a grass-roots effort. For months, students collected ticket stubs from Pittsburgh cultural events. The result is a monument to the strength and vibrancy of the Pittsburgh region's cultural scene—and that of the student body at Shaler Area High School.

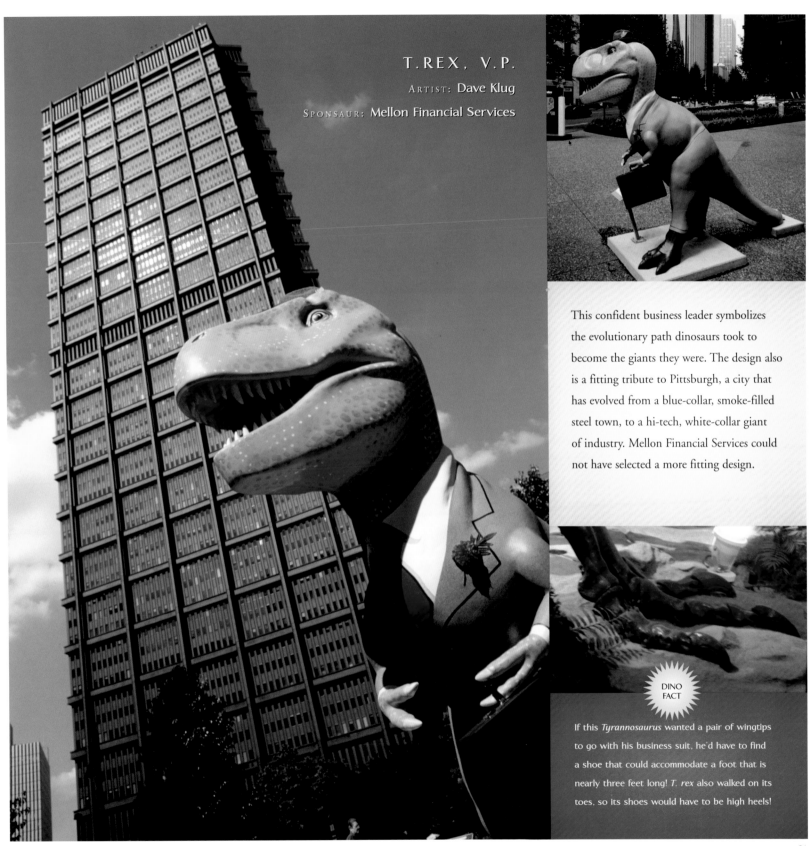

T. REX, V.P.

ARTIST: Dave Klug

SPONSAUR: Mellon Financial Services

This confident business leader symbolizes the evolutionary path dinosaurs took to become the giants they were. The design also is a fitting tribute to Pittsburgh, a city that has evolved from a blue-collar, smoke-filled steel town, to a hi-tech, white-collar giant of industry. Mellon Financial Services could not have selected a more fitting design.

DINO FACT

If this *Tyrannosaurus* wanted a pair of wingtips to go with his business suit, he'd have to find a shoe that could accommodate a foot that is nearly three feet long! *T. rex* also walked on its toes, so its shoes would have to be high heels!

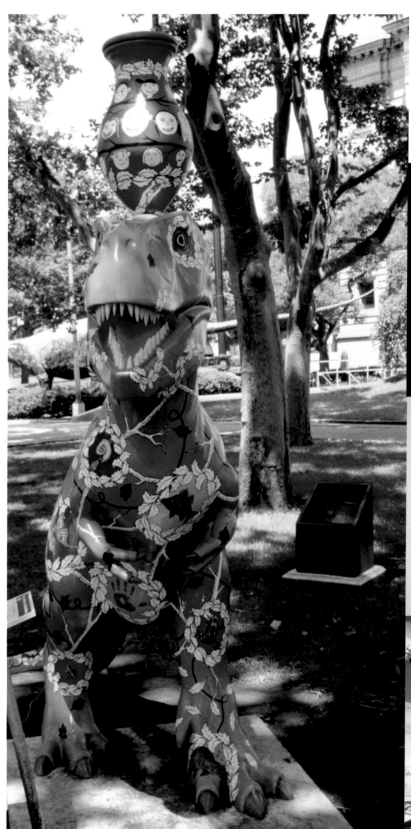

CONNECTIONS

ARTIST: Patricia Bellan-Gillen

SPONSAUR: The Laurel Foundation

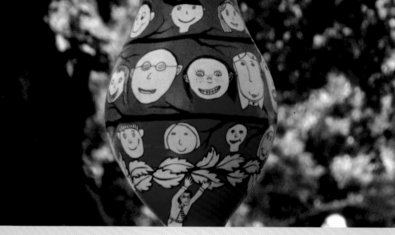

Tenured CMU art professor Patricia Bellan-Gillen's creation "Connections" was inspired by the natural world. "I wanted to convey the connections that all living things have through nature," said Bellan-Gillen. The design also pays tribute to the collections of Carnegie Museum of Natural History, as all of its major collections are represented in the design. Fourth-grade students from Burgettstown Area Elementary painted self-portraits, which Bellan-Gillen incorporated into the classical urn attached to the head of the *T. rex*.

DINO FACT

In addition to its dinosaur brethren, *Tyrannosaurus rex* shared its world with many other kinds of animals. Tiny mammals scampered beneath its feet, while pterosaurs and birds soared above its head.

T. REX RAY

ARTIST: **Ashley Hodder with Children from Children's Hospital of Pittsburgh**

SPONSAUR: **PNC Bank**

"T.reX Ray" gave children at Children's Hospital of Pittsburgh an opportunity to imagine what might be revealed inside the body of a *T. rex* if one could be x-rayed. Their work turns into an x-ray device itself, as we are given a chance to look inside the imaginations of these children.

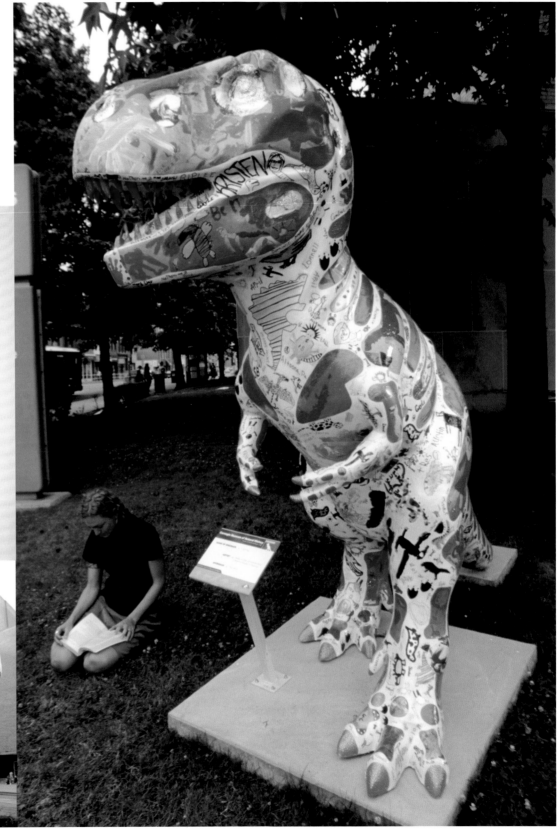

MR. DIG

ARTIST: **Glennis McClellan**

SPONSAUR: **The Hillman Company**

Utilizing a unique combination of sculpting and *trompe l'oeil* techniques, the artist drew on her expertise in murals to create a realistic-looking excavation scene, straight from the dig site. A crew of miniature paleontologists is rendered scraping and dusting fossilized bones. Real rocks at the base of the sculpture add to the realism of the scene.

This fascinating puzzle of birds, from modern to most ancient, is absolutely captivating. Beginning at the tail with *Archaeopteryx*, the oldest known bird, the story of the ancestry of birds as it relates to dinosaurs is told in living color. Winchester Thurston students were responsible for researching each bird and ensuring its accurate depiction on the dinosaur.

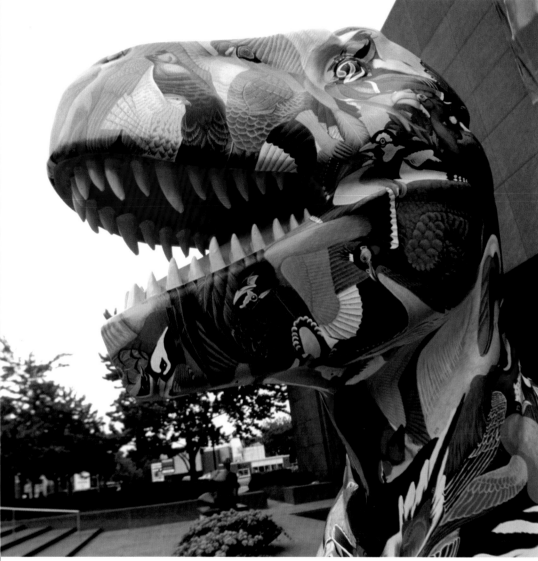

DINO-SOAR

ARTIST: **Winchester Thurston School**

SPONSAUR: **Winchester Thurston School**

DINO FACT

T. rex lives on at your birdfeeder! Many unique similarities in the skeletons of meat-eating dinosaurs and birds provide strong evidence that birds descended from dinosaurs.

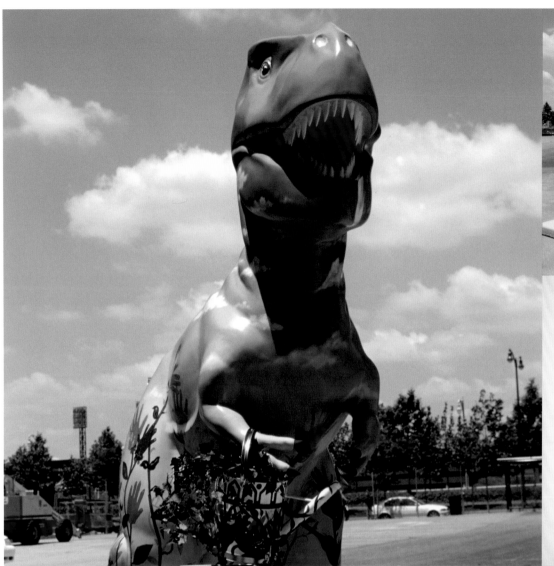

Inspired by the quote, "in the garden of life, you are a flower of love," inpatients, outpatients, and day school students at the Children's Institute created this fabulous garden. Vines connect the handprint flowers as the children's families and Children's Institute staff help to connect the children to their full potential.

AMAZING HANDS

ARTIST: The Children's Institute — Terri Draghi

SPONSAUR: Alco Parking Corporation

DINO FACT

T. rex was once hailed as the largest meat-eater that ever lived on land. It has now been dethroned by two even larger predatory dinosaurs, *Carcharodontosaurus* from North Africa, and *Giganotosaurus* from Argentina, both of which were longer than *T. rex*. *Giganotosaurus* was also more heavily built than *T. rex* and, to make things worse, may have hunted in packs!

ELEMENTARYSAURUS

ARTIST: O'Hara Elementary School—
Paul Noro and Mark Dellert

SPONSAUR: NOVA Chemicals

Of all of the dinosaur designs generated by students of O'Hara Elementary, one stood out in the eyes of the DinoMite Days jury committee. That design, created by fourth grader Madeline Docimo, won the school one of three dinosaurs given to public schools in the region. The dinosaur is covered in the flurry of paper with which any student can identify on a daily basis.

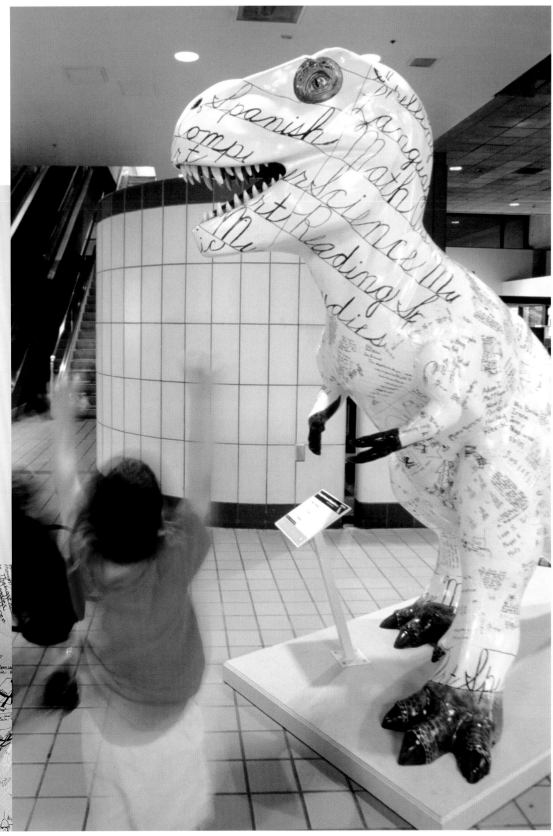

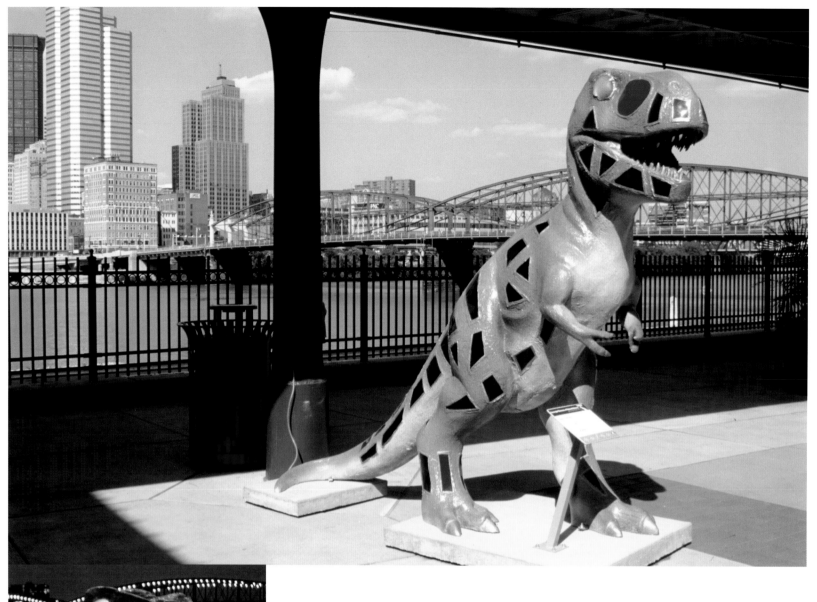

LUNASAURUS LUX

ARTIST: **Jason Gotsch**

SPONSAUR: **Station Square, Forest City Management**

As Gotsch conceived this design, he considered how a dinosaur would look if it had evolved in an urban setting, among steel and concrete, instead of rocks and prehistoric vegetation. The dinosaur, a metaphor for the past, is reconsidered in the future tense using plastic sheeting, stained glass, and internal lighting. Plexiglas® scales illuminated from within changed the appearance of the dinosaur throughout the day and night.

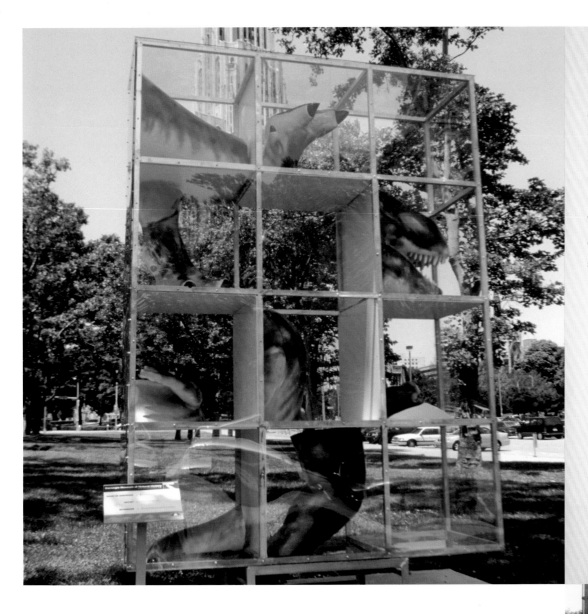

In true scientific form, Gregory Karkowsky took the scientific sample *T. rex* and dissected it, symbolically reconstructing the scramble in which the bones must have first been discovered. It becomes up to the viewer, then, to play paleontologist and try to imagine the beast in its original form. This contemporary reconstruction of fossil elements utilizes one-inch square extruded aluminum tubing and clear Lexan® panels.

RUBIX-O-SAURUS

ARTIST: **Gregory Karkowsky**

SPONSAUR: **Carnegie Museum of Natural History**

DINO FACT

Assembling a dinosaur skeleton is like putting together a jumbo jigsaw puzzle. Instead of slots and tabs, scientists rely on evidence such as areas of muscle attachment and joint articulations between bones, as well as careful comparisons with the skeletons of other related animals.

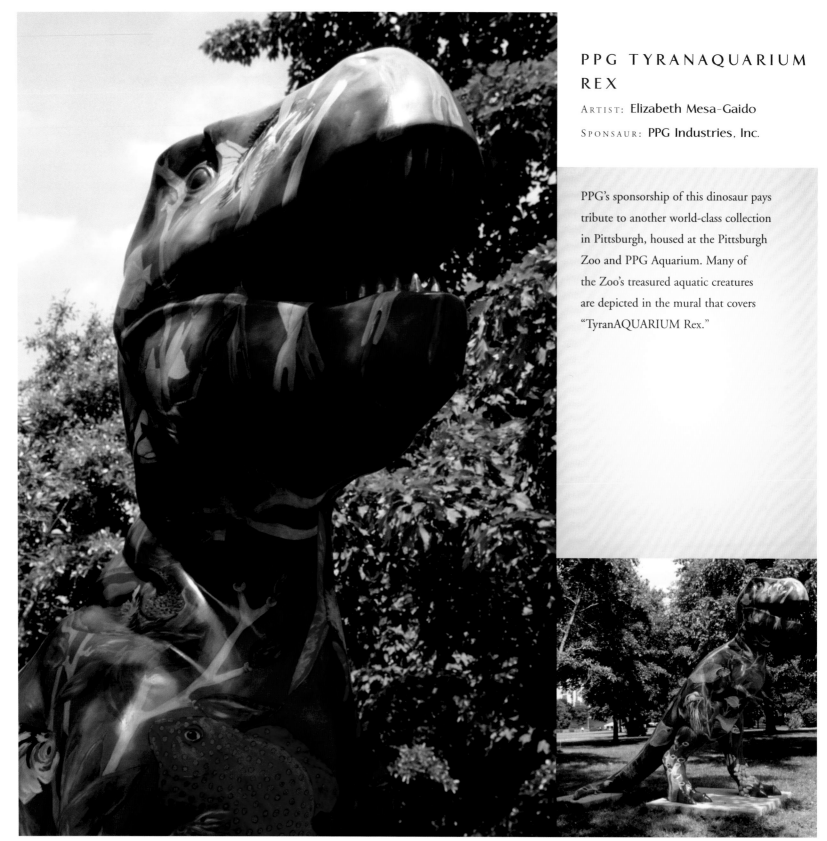

PPG TYRANAQUARIUM REX

ARTIST: Elizabeth Mesa-Gaido

SPONSAUR: PPG Industries, Inc.

PPG's sponsorship of this dinosaur pays tribute to another world-class collection in Pittsburgh, housed at the Pittsburgh Zoo and PPG Aquarium. Many of the Zoo's treasured aquatic creatures are depicted in the mural that covers "TyranAQUARIUM Rex."

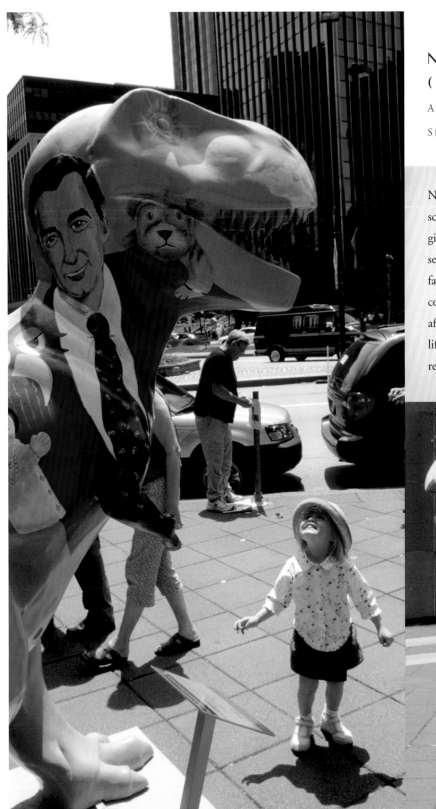

NEIGHBORSAURUS 143
(I LOVE YOU)

ARTIST: Family Communications Art Crew

SPONSAUR: The Laurel Foundation

No one understood children and how to teach them the value of art, science, history, and imagination like Fred Rogers. In memory of this giant of a man, a national treasure, the art team responsible for creating sets for his show for decades depicted characters and scenes from their favorite memories of Mr. Rogers. Included in the design is Fred Rogers' code for "I love you," the numerals 1, 4, and 3. Grateful for the love and affection he demonstrated to them and to his show's audiences during his lifetime, the Family Communications team and The Laurel Foundation returned the favor through "Neighborsaurus."

TEA REX

ARTIST: **Amy Soich**

SPONSAUR: **Christine Toretti Olson**

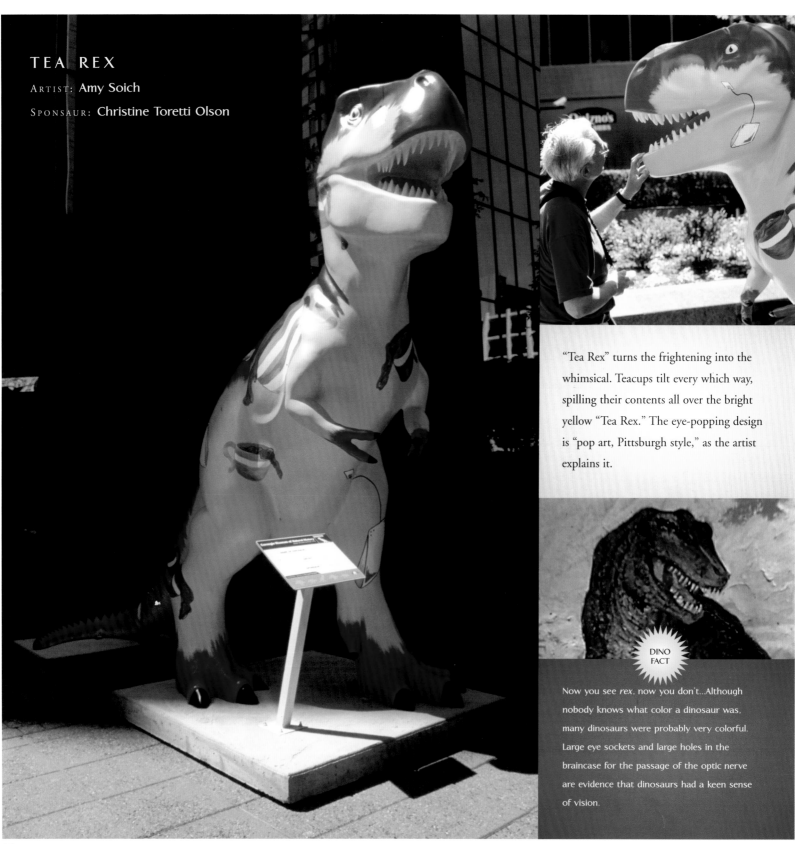

"Tea Rex" turns the frightening into the whimsical. Teacups tilt every which way, spilling their contents all over the bright yellow "Tea Rex." The eye-popping design is "pop art, Pittsburgh style," as the artist explains it.

DINO FACT

Now you see *rex*, now you don't...Although nobody knows what color a dinosaur was, many dinosaurs were probably very colorful. Large eye sockets and large holes in the braincase for the passage of the optic nerve are evidence that dinosaurs had a keen sense of vision.

WHAT'S FOR DINNER?

ARTIST: FORAXIS Design Solutions, LLC and Raluca Vescan

SPONSAUR: Giant Eagle, Inc.

This whimsical design presents grocery shopping millions of years ago. This Mesozoic mama pushes a cart filled with tasty *Tyrannosaurus* treats including pterodactyl wings and *Stegosaurus* eggs. Tonight is family night back at the *T. rex* place, so Mom has picked out a few videos, such as "Sleepless in Pangaea" and "Chew Hard with a Vengeance." She also could not resist the temptation of the checkout tabloids, having picked up a stone scandal sheet with the sensational headline, "Human Sighting!"

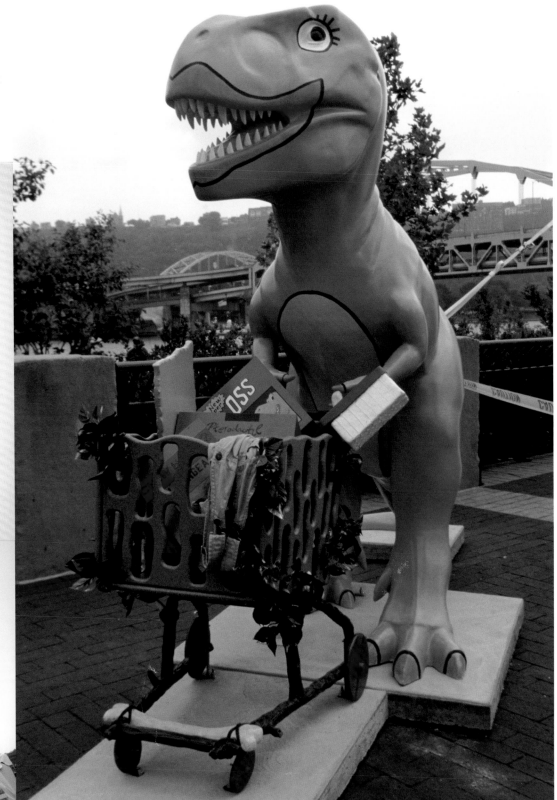

SPLATASAURUS

ARTIST: **Chuck Dill**

SPONSAUR: **Pittsburgh Steelers**

If Jack Lambert were a dinosaur, he would definitely be *Tyrannosaurus rex!* He sports an intimidating grin like that of "Jack Splat." A tribute to the Steelers Hall of Fame linebacker, this gridiron growler would have a claw for each of #58's four Super Bowl rings.

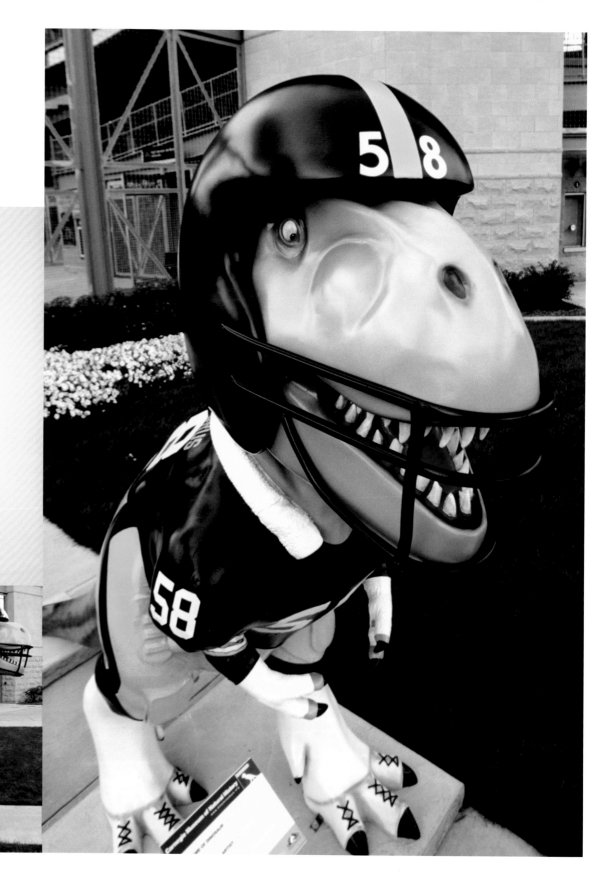

Stegosaurus

Stegosaurus is a reptilian cross between a Sherman tank and a Swiss army knife. This dinosaur's unique physical architecture is a three-dimensional fortress of body armor, plates, and spikes. *Stegosaurus* was one of the more common North American dinosaurs of the Late Jurassic period (156–140 million years ago). These dinosaurs spent most of their time lumbering around in search of enough vegetable material to fuel their hulking frames. Among the staples on its Jurassic menu were ferns, mosses, cycads, horsetails, and conifers. The regiment of huge, bony plates parading up and down *Stegosaurus'* back is its most distinctive feature. In addition to protecting the dinosaur's back, the bony plates were full of channels for blood vessels. Most likely, the plates served as a central heating and cooling system, conducting heat to and from the large animal's body. Millions of years before the Knights of the Round Table, *Stegosaurus* sallied forth into the Jurassic protected by chain mail of its own. Bony studs on the hips, thighs, and tail shielded the skin from the claws and teeth of predators, while allowing it to remain quite flexible. The most formidable weapon in the *Stegosaurus* arsenal was the spike-studded, mace-like tail.

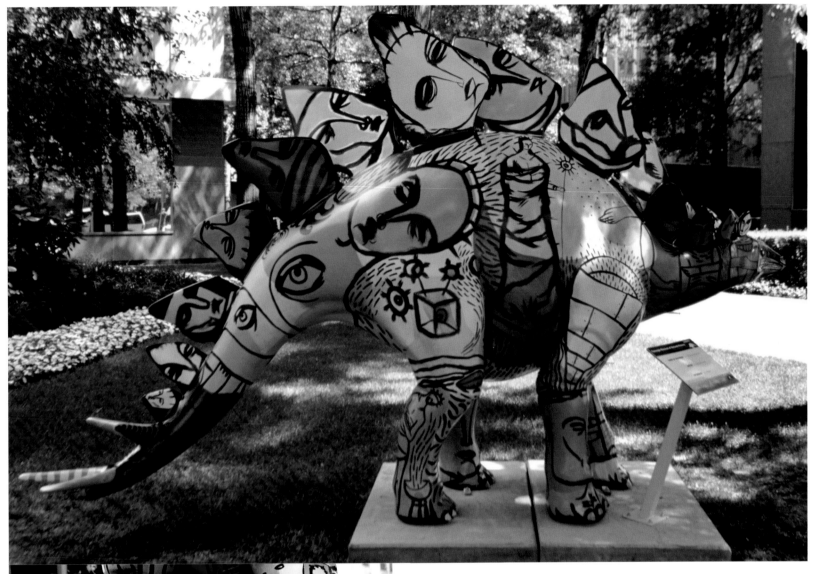

ANTHROPOMORPHISAURUS

<small>ARTIST:</small> **Michael Lotenero**

<small>SPONSAUR:</small> **Kolbrener, Inc.**

The shape of *Stegosaurus'* plates lends itself perfectly to the artist's favorite subject—faces. A figurative, almost abstract style and bright colors combine to give the creature human characteristics, thus the name, "Anthropomorphisaurus."

HISTORAPOD

ARTIST: **Chris Smith**

SPONSAUR: **Ketchum**

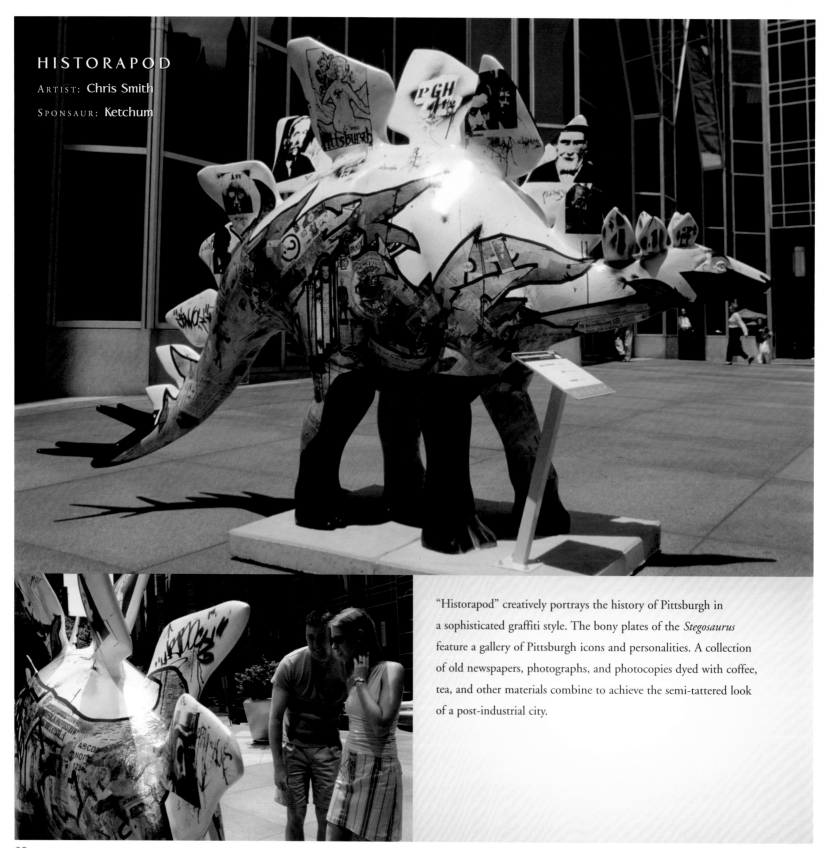

"Historapod" creatively portrays the history of Pittsburgh in a sophisticated graffiti style. The bony plates of the *Stegosaurus* feature a gallery of Pittsburgh icons and personalities. A collection of old newspapers, photographs, and photocopies dyed with coffee, tea, and other materials combine to achieve the semi-tattered look of a post-industrial city.

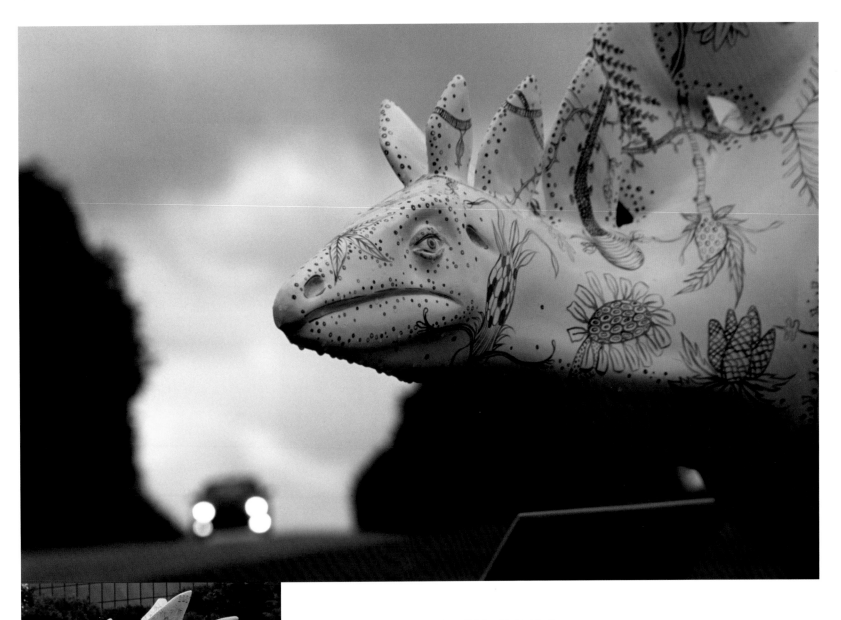

STEGOSAURUS EN TOILE

ARTIST: Laura Sharp Wilson

SPONSAUR: L.B. Foster Company

"Stegosaurus en Toile" is influenced by the popular French *toile* fabric. Typical *toile* motifs often tell a story, such as vignettes of rural life, historical events, mythology, and pastoral scenes. This *toile*, however, depicts vegetation that would have grown during *Stegosaurus'* lifetime in the late Jurassic— cycads, conifers, ginkgoes, seed ferns, and angiosperms.

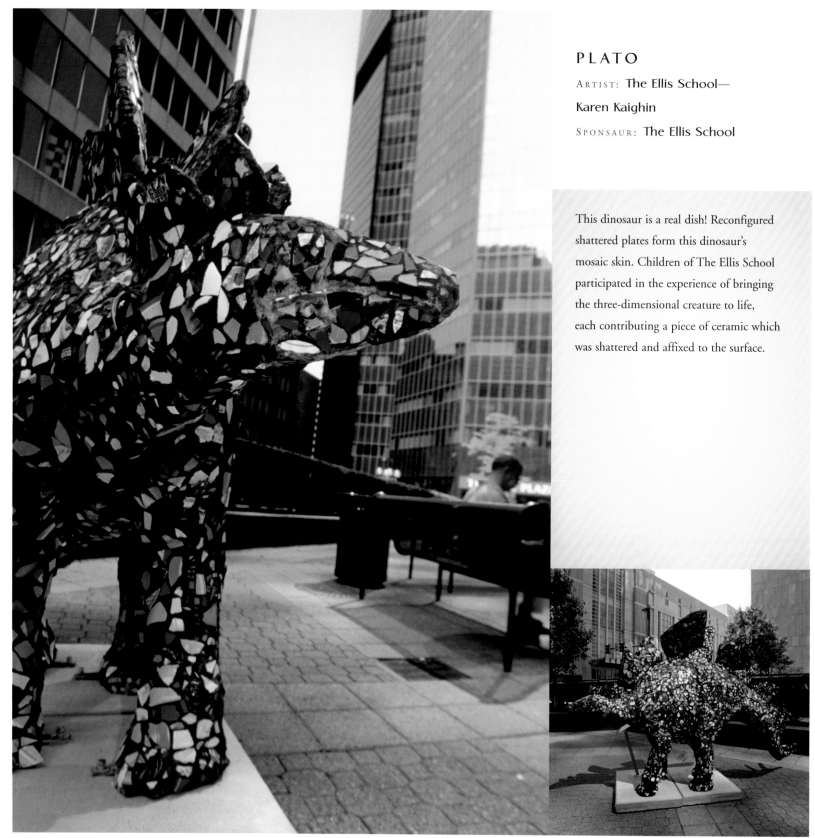

PLATO

ARTIST: **The Ellis School—** Karen Kaighin

SPONSAUR: **The Ellis School**

This dinosaur is a real dish! Reconfigured shattered plates form this dinosaur's mosaic skin. Children of The Ellis School participated in the experience of bringing the three-dimensional creature to life, each contributing a piece of ceramic which was shattered and affixed to the surface.

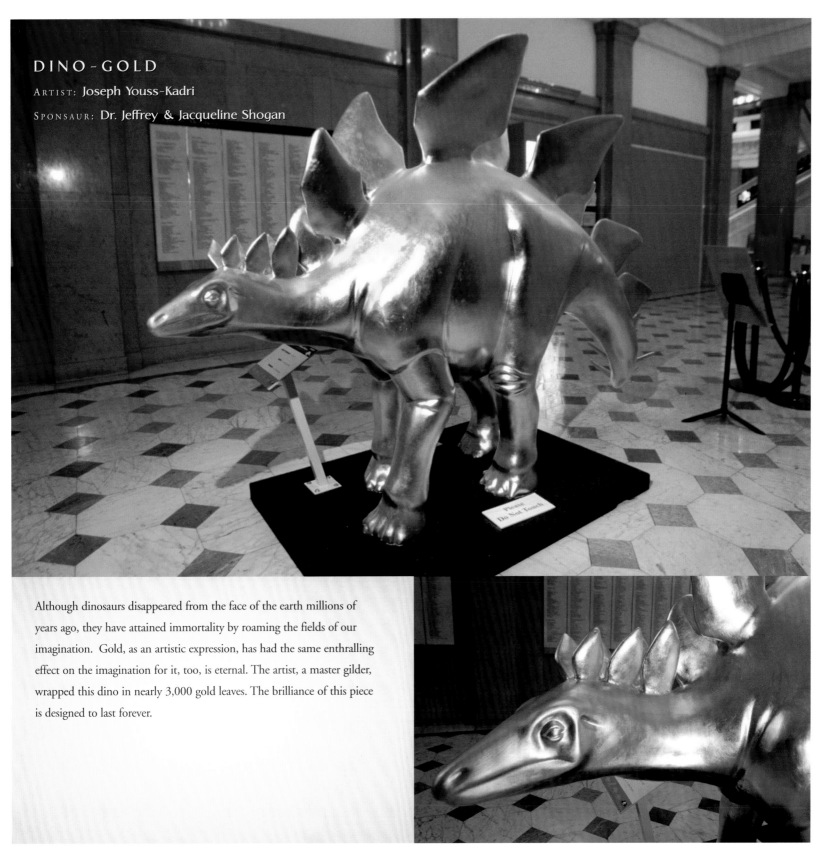

DINO-GOLD

ARTIST: Joseph Youss-Kadri

SPONSAUR: Dr. Jeffrey & Jacqueline Shogan

Although dinosaurs disappeared from the face of the earth millions of years ago, they have attained immortality by roaming the fields of our imagination. Gold, as an artistic expression, has had the same enthralling effect on the imagination for it, too, is eternal. The artist, a master gilder, wrapped this dino in nearly 3,000 gold leaves. The brilliance of this piece is designed to last forever.

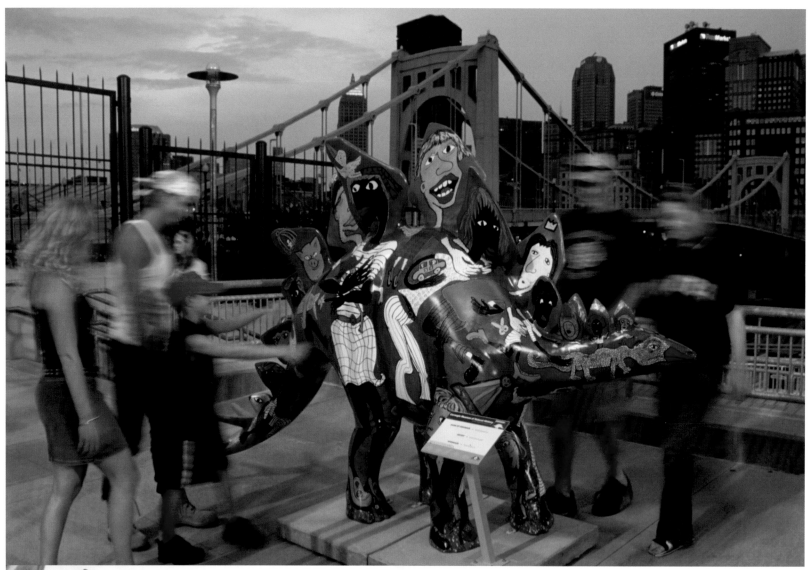

SCHLUMPOSAURUS

ARTIST: **Laura McLaughlin**

SPONSOR: **Giant Eagle, Inc.**

This dinosaur focuses on the people of Pittsburgh. Colorful characters define the diversity and unique qualities of the city's residents. Non-human forms inhabit the design, as well, vibrantly filling the form of the dinosaur.

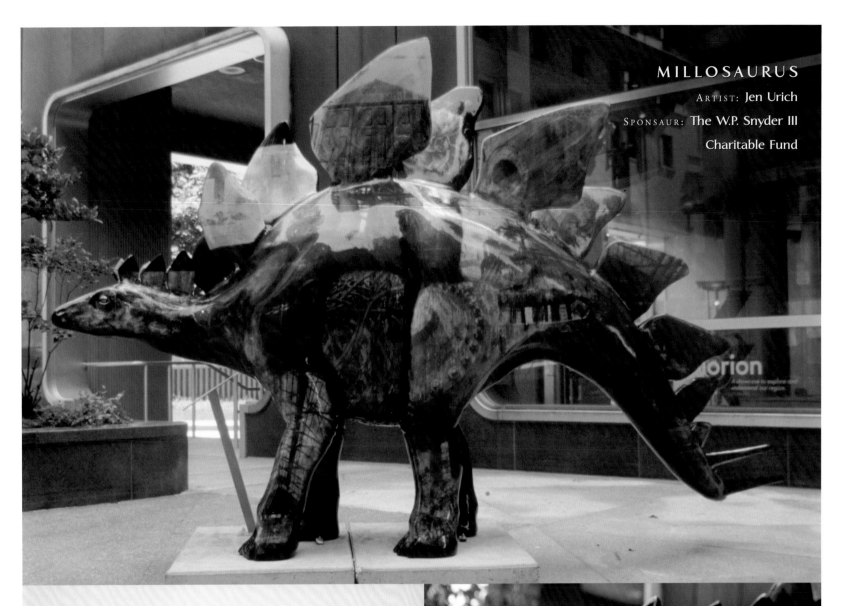

MILLOSAURUS

ARTIST: **Jen Urich**

SPONSAUR: **The W.P. Snyder III Charitable Fund**

An era of Pittsburgh history is captured forever through a unique process. First, the artist photographed abandoned steel mills—a building block of Pittsburgh that verges on extinction. These photos were then adhered to the dinosaur using a two-step photographic emulsion process. The method gives a ghostly appearance that evokes slightly blurred and wistful thoughts about this significant part of the region's heritage.

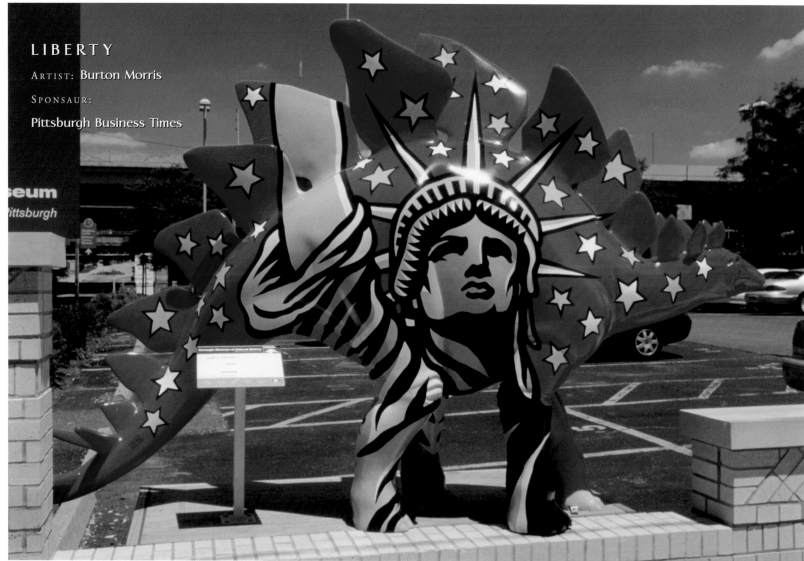

LIBERTY

ARTIST: **Burton Morris**

SPONSAUR:

Pittsburgh Business Times

I WANT YOU

ARTIST: **Burton Morris**

SPONSAUR: **CB Richard Ellis**

Pittsburgh native Burton Morris' dynamic pop art style is immediately recognizable. These star-spangled dinosaurs, featuring American icons Uncle Sam and the Statue of Liberty, proudly show their patriotic colors.

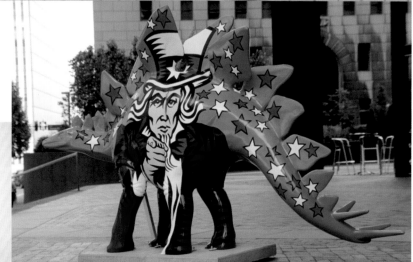

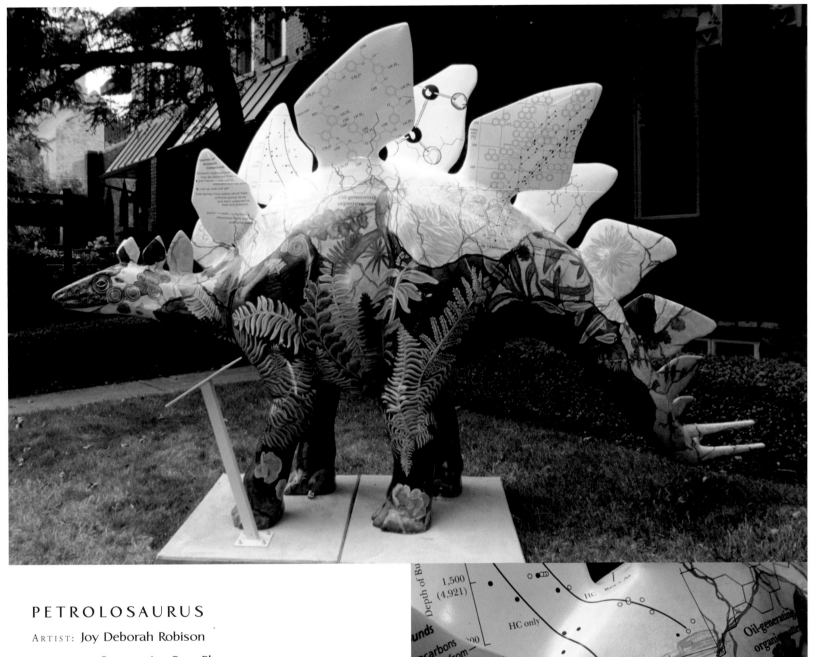

PETROLOSAURUS

ARTIST: **Joy Deborah Robison**

SPONSAUR: **Community Care Plus**

The design of this dinosaur stems from the process that created the fossil fuels we use today. Fern forests sprout upward, recalling the plant matter origins of fuel. The top of the dinosaur is decorated with illustrations of the chemical processes that create petrochemicals.

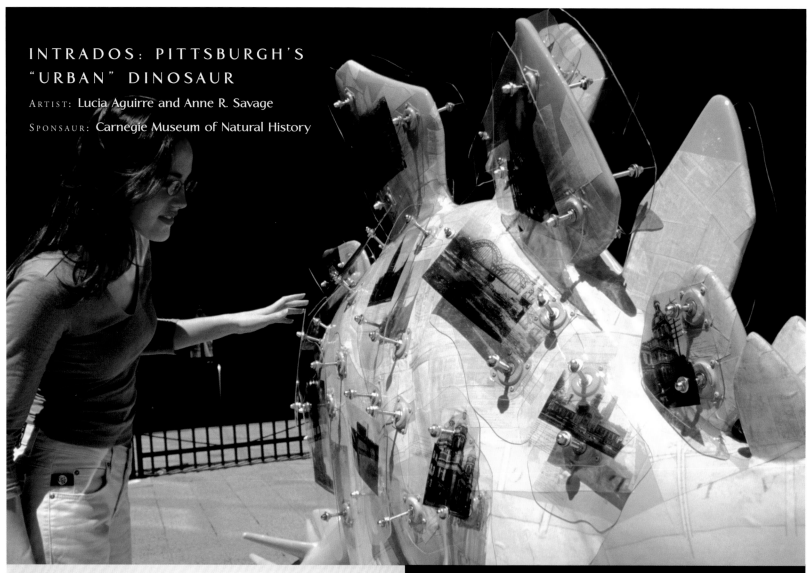

INTRADOS: PITTSBURGH'S "URBAN" DINOSAUR

ARTIST: **Lucia Aguirre and Anne R. Savage**

SPONSAUR: **Carnegie Museum of Natural History**

This dinosaur is a monument to the beauty and evolution of Pittsburgh's urban landscape. Just like the dinosaurs, Three Rivers Stadium and the Brady Street Bridge have disappeared, but live on in memory. Historic buildings like the Allegheny County Courthouse and the Gulf Tower survive as architectural mainstays. Plexiglas® "armor" features images of places worth protecting and those already extinct.

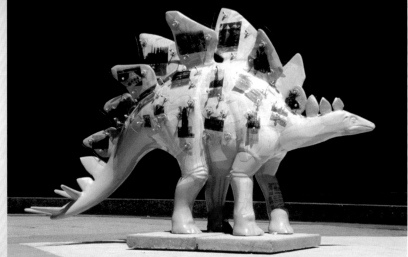

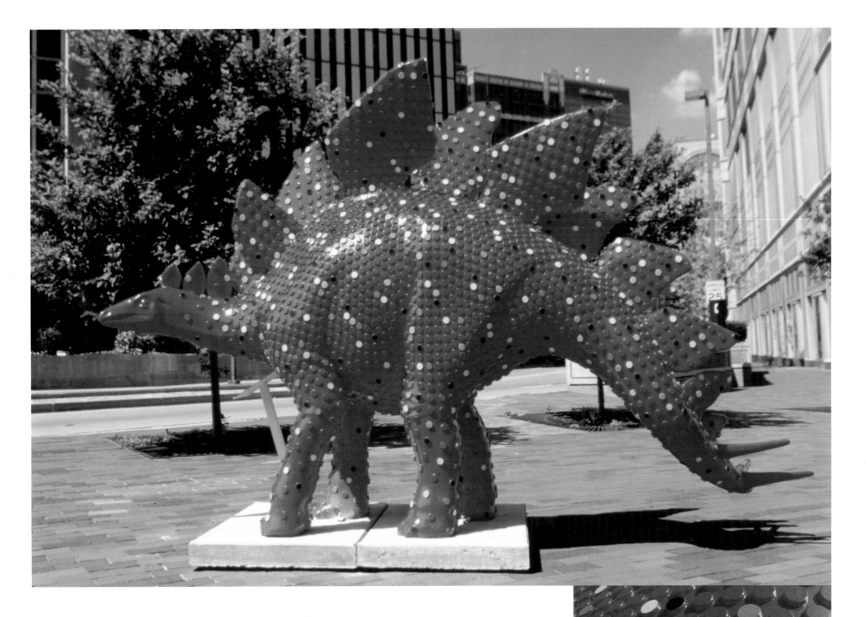

DOT DINOSAUR

ARTIST: **Anne Lopez**

SPONSAUR: **Broudy Printing Inc.**

The dots in this dinosaur's design are fraught with symbolism. Identical and regimented polka dots are unlike any decoration in nature, but evoke natural patterns such as those found on trout and jungle cats. Photos reproduced in printed pieces are also comprised of many small dots, which, from a distance, give the perception of a completed image. The color scheme of the dots reflects the standard palette of color printing—cyan, magenta, yellow, and black.

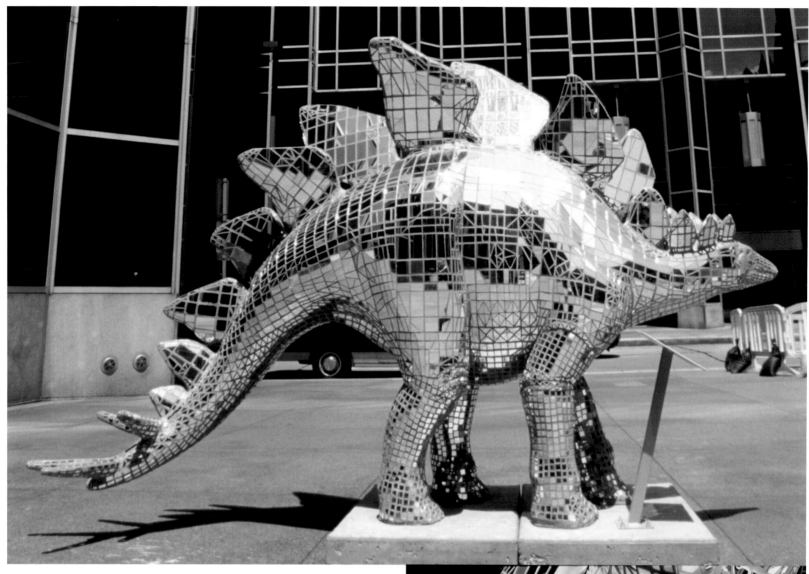

PHILIPOSAURUS @ PPG

ARTIST: **Gary Mesa-Gaido**

SPONSAUR: **PPG Industries, Inc.**

This glittering, glass mosaic masterpiece, made of cut pieces of mirror, is reminiscent of another shining beacon of creativity and ingenuity: Philip Johnson's PPG Place in Downtown Pittsburgh. Both reflect Pittsburgh brilliantly.

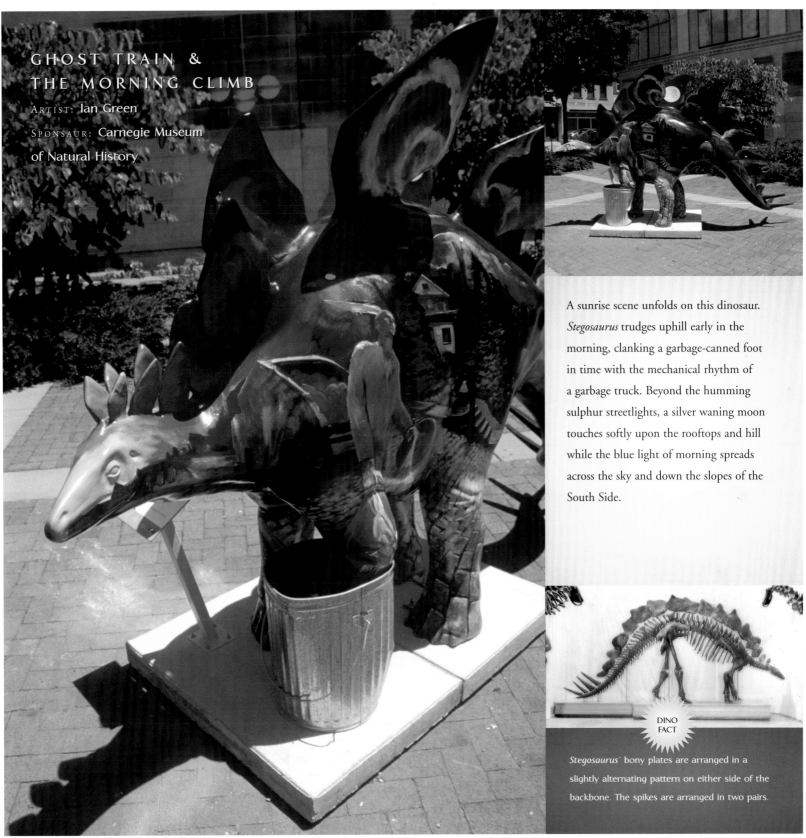

GHOST TRAIN &
THE MORNING CLIMB

ARTIST: Ian Green

SPONSOR: Carnegie Museum
of Natural History

A sunrise scene unfolds on this dinosaur. *Stegosaurus* trudges uphill early in the morning, clanking a garbage-canned foot in time with the mechanical rhythm of a garbage truck. Beyond the humming sulphur streetlights, a silver waning moon touches softly upon the rooftops and hill while the blue light of morning spreads across the sky and down the slopes of the South Side.

DINO
FACT

Stegosaurus' bony plates are arranged in a slightly alternating pattern on either side of the backbone. The spikes are arranged in two pairs.

SPECTRASAURUS

ARTIST: John Peter Glover

SPONSAUR: Medrad, Inc.

The color scheme of "Spectrasaurus" mimics the colors that brightly hued poisonous tree frogs use to warn predators. Bright colors in the tail-spike region of this *Stegosaurus* might serve as a similar warning. The free-flowing, intricately drawn lines are harmonious with the dinosaur's contours, and suggest the deeper complexities of nature, up close.

STEPPIN' OUT IN THE 'BURGH

ARTIST: Nellie Lou Slagle

SPONSAUR: Carnegie Museum of Natural History

This *Stegosaurus* is stepping out in style! Accentuated with ruby red lips and toes, her chartreuse woven dress—a garment highlighted with multicolored telephone wires—is perfectly set off by her matching jewelry, an assortment of bangles and trinkets.

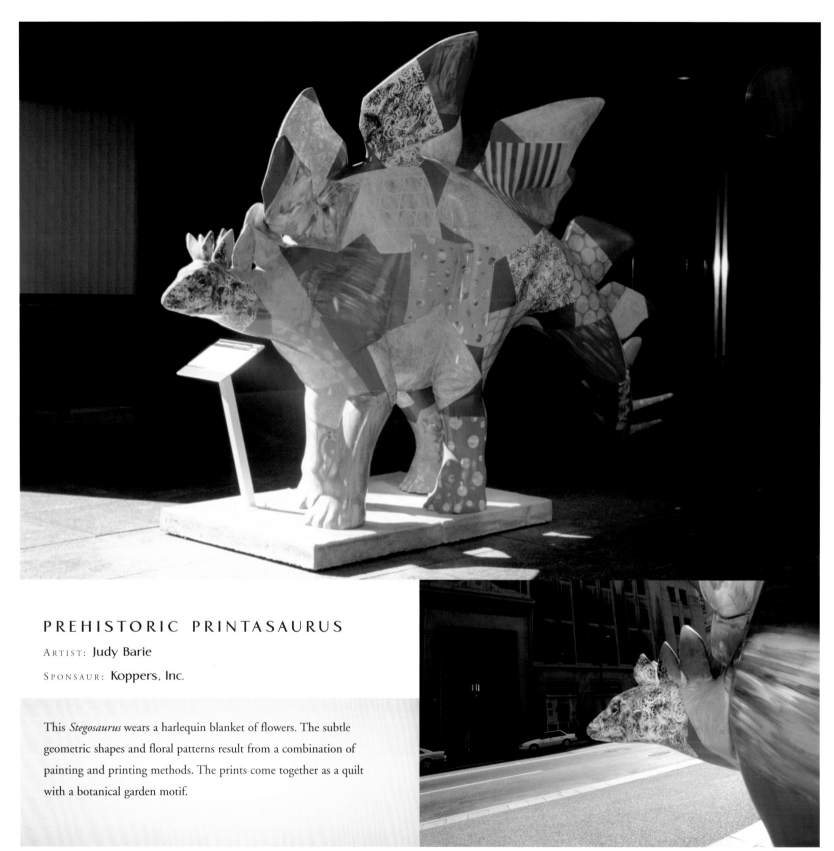

PREHISTORIC PRINTASAURUS

Artist: **Judy Barie**

Sponsaur: **Koppers, Inc.**

This *Stegosaurus* wears a harlequin blanket of flowers. The subtle geometric shapes and floral patterns result from a combination of painting and printing methods. The prints come together as a quilt with a botanical garden motif.

THE BURGHOSAURUS

ARTIST: Patricia Calderone

SPONSOR: PNC Bank

The patterns in this dinosaur's skin seem simple from a distance. Upon closer inspection, detailed present-day images emerge. Similarly, some visitors to Pittsburgh arrive expecting a ghost town mired in its smoky past and are surprised and delighted to find an intriguing high-tech city full of color and confidence.

DINO FACT The tail spikes of *Stegosaurus* are known as thagomizers. This scientific term has its origins in a comic strip. In one of Gary Larson's "The Far Side" cartoons, a Neanderthal professor explains that the end of a *Stegosaurus*' tail is called a thagomizer, named for a caveman colleague, the late Thag Simmons.

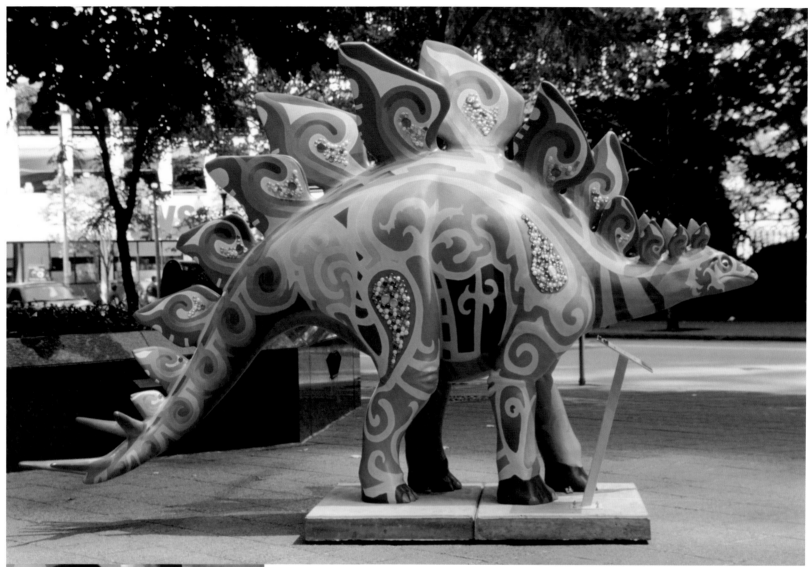

FABOSAURUS

ARTIST: **Jill MacKay**

SPONSOR: **Massaro Company**

This dinosaur begs the question, "Which came first, the dinosaur or the Fabergé egg?"
This Fabergé-style dinosaur wears a coat of stylized paint. Highly detailed mosaic sections comprised
of colored glass and mirror provide rich detail and reflective sources for light, bringing sparkle and life
to the design.

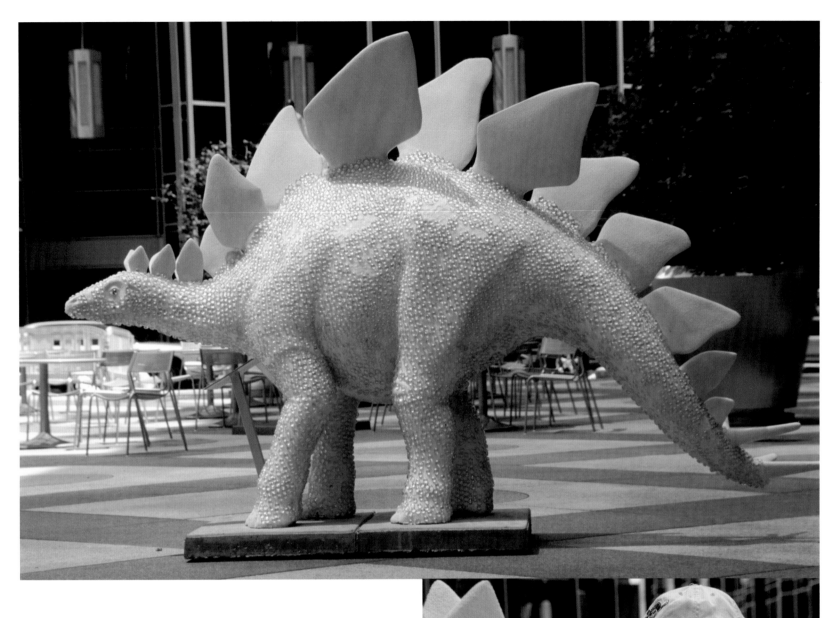

JURASSIC JEWEL

ARTIST: **William Donovan**

SPONSAUR: **The Hillman Company**

The entire surface of this gem of a dinosaur is encrusted with translucent glass. The blue and green undertones of the glass added to an acrylic foundation create a glistening jewel of immense scale and splendor.

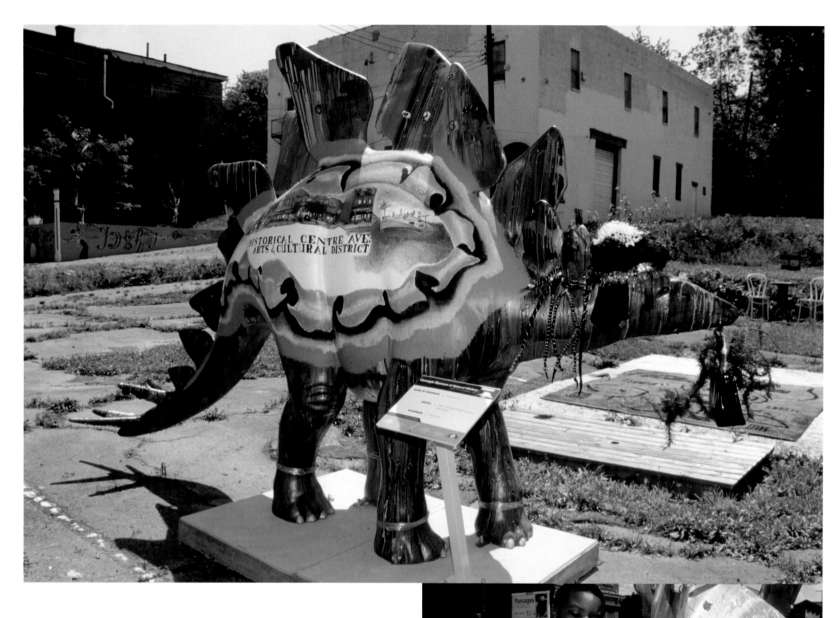

JAZZOSAURUS

ARTIST: **Jorge Meyers with Children from CMU's Role Models Program** SPONSAUR: **PNC Bank**

Historic Centre Avenue is brought to life vividly in this very jazzy design. Children from Carnegie Mellon University's Role Models program gained hands-on experience while assisting in the creation of this very upbeat character.

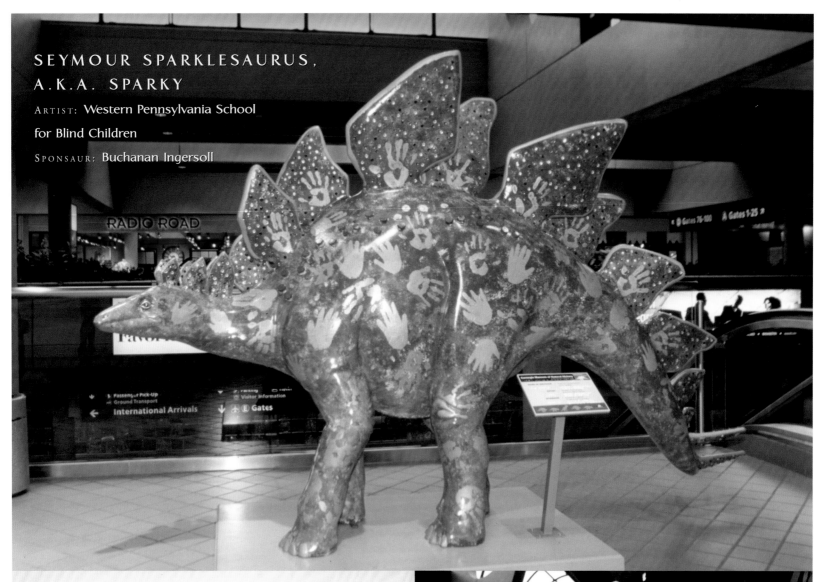

SEYMOUR SPARKLESAURUS,
A.K.A. SPARKY

ARTIST: Western Pennsylvania School
for Blind Children

SPONSAUR: Buchanan Ingersoll

Students at the Western Pennsylvania School for Blind Children sponged their school colors—teal and purple—onto Sparky's surface. They then applied their own touch to the project, placing golden handprints onto Sparky's belly and back. For those who experience this three-dimensional art through their fingertips, Sparky's name is spelled in Braille along his back.

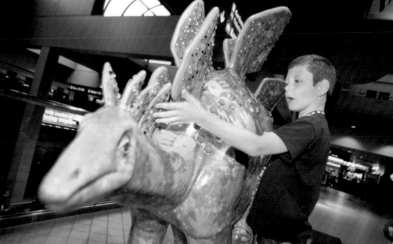

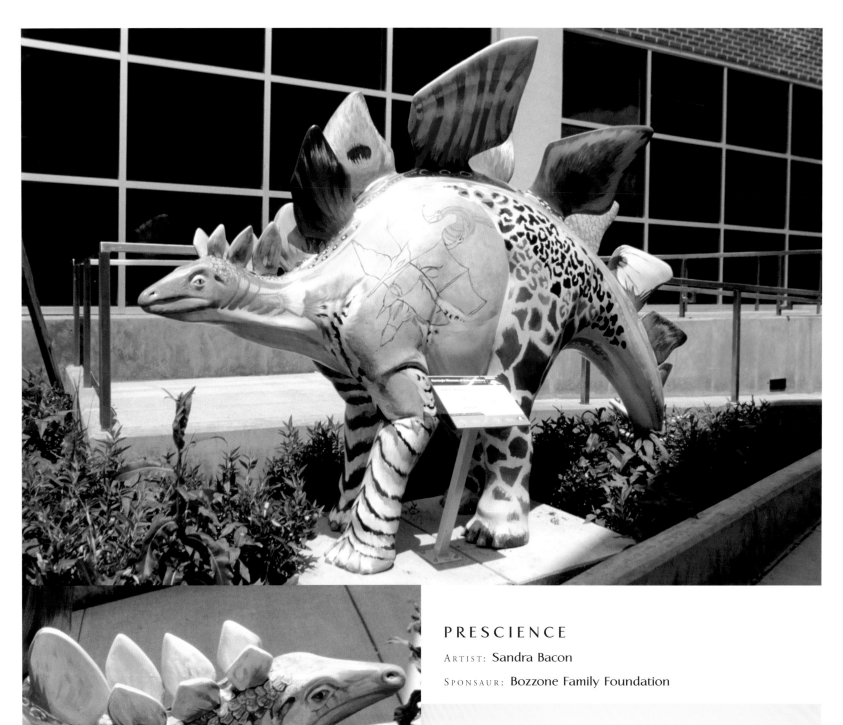

PRESCIENCE

ARTIST: **Sandra Bacon**

SPONSAUR: **Bozzone Family Foundation**

Embedded in the DNA of the dinosaurs was the raw material of animal life to come. This *Stegosaurus* hints at the animals that would follow it in the parade of life. The painted surface is a collage of imagery from all the animal kingdoms, including depictions of reptilian skin, amphibian fins, and luminescent insect wings.

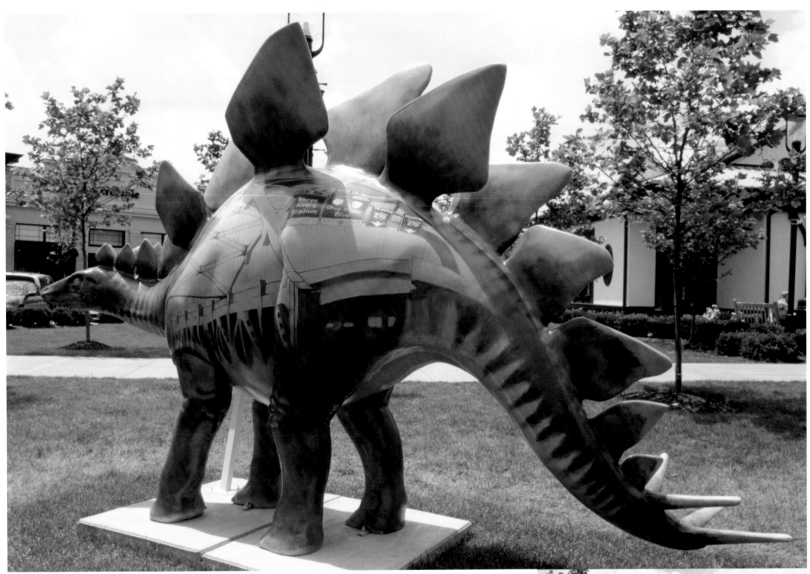

BRIDGEOSAURUS

ARTIST: **Michael Hogle**

SPONSAUR: **PNC Bank**

Pittsburgh's many bridges are arguably the city's most evocative images. The structures of the Fort Duquesne and Fort Pitt Bridges parallel the curved back of *Stegosaurus*. Transposing the images of these iconic spans from Pittsburgh's Point resonates between the natural past and engineering present.

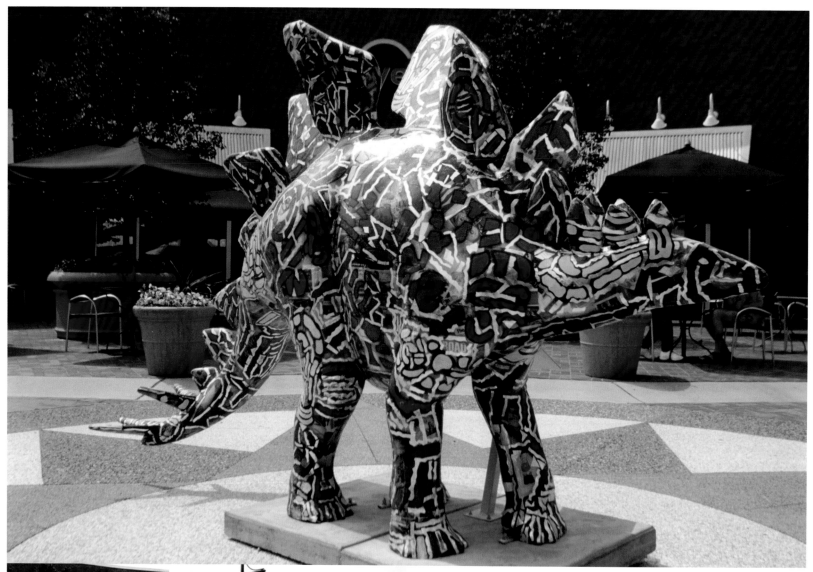

COGITATIO AETERNA

ARTIST: Glen Whittaker

SPONSAUR: Joseph and Violet Soffer Foundation

Translated from the Latin, the title of this dinosaur means "eternal reflection." Among the collage of images are literal and symbolic keys that encourage the viewer to ponder natural relationships and how they complement one another. Silicone applied to the collaged surface provides a tactile experience, giving the skin a realistic, rubbery feel.

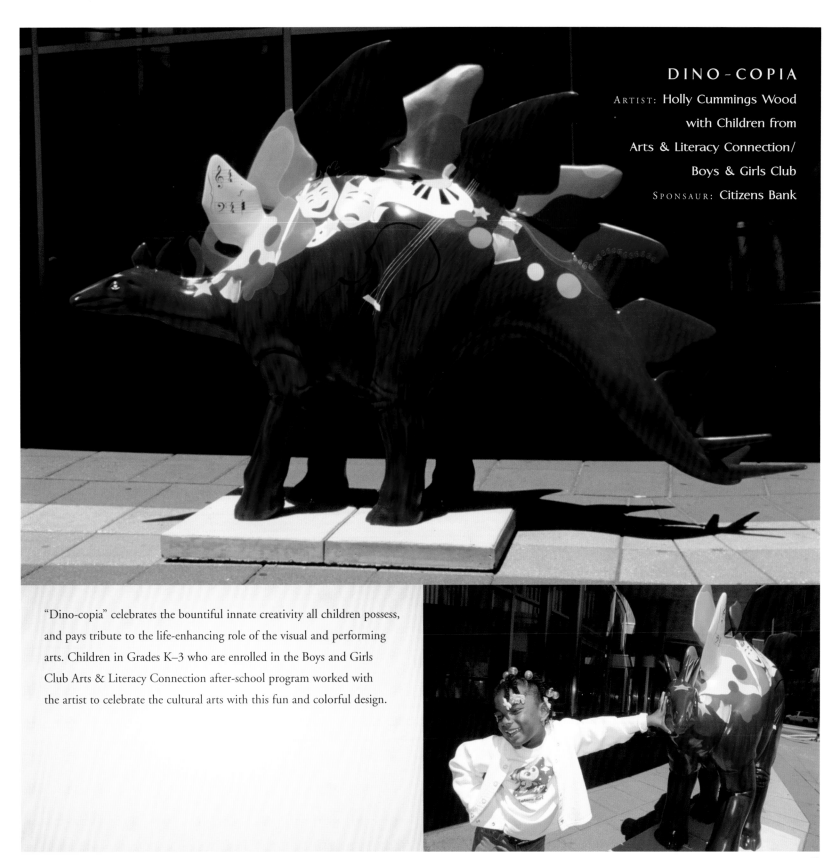

ARTIST: Holly Cummings Wood
with Children from
Arts & Literacy Connection/
Boys & Girls Club
SPONSAUR: Citizens Bank

"Dino-copia" celebrates the bountiful innate creativity all children possess, and pays tribute to the life-enhancing role of the visual and performing arts. Children in Grades K–3 who are enrolled in the Boys and Girls Club Arts & Literacy Connection after-school program worked with the artist to celebrate the cultural arts with this fun and colorful design.

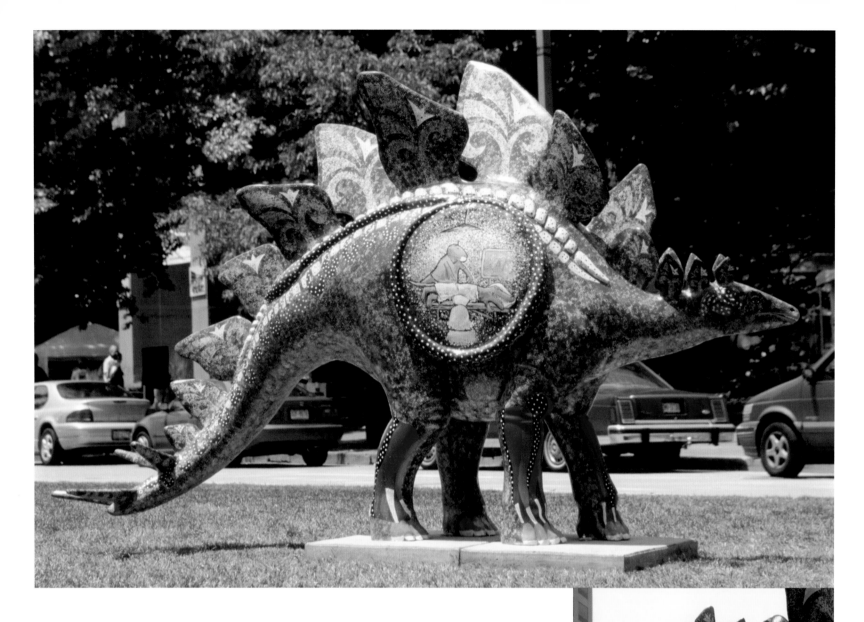

NEUROSAURUS

ARTIST: Mike George

SPONSAUR: Surgical Neuromonitoring Associates, Inc.

This nervy creature offers a peek into the dinosaur ER. It makes one wonder how modern medical science may have benefited the doomed creatures. The design also highlights the animal's brain, spine, and nervous system.

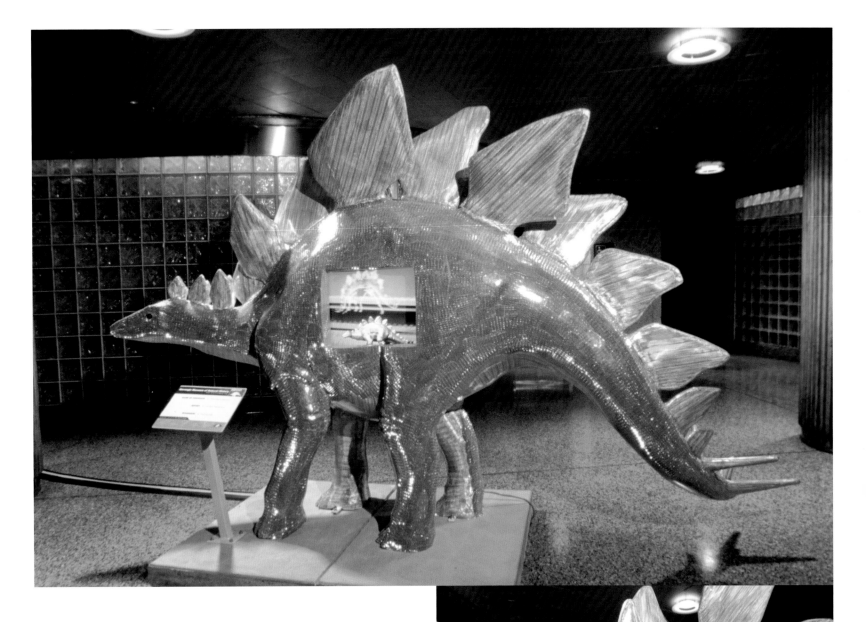

RENAISSANCEOSAURUS

ARTIST: **Port Authority Creative Department**

SPONSAUR: **Port Authority of Allegheny County**

Glittering scales cover this modern interpretation of *Stegosaurus*.
A monitor on its side shows a video of dinosaurs coming back to life on
the streets of Pittsburgh. The old and the new merge together and move
forward into the future.

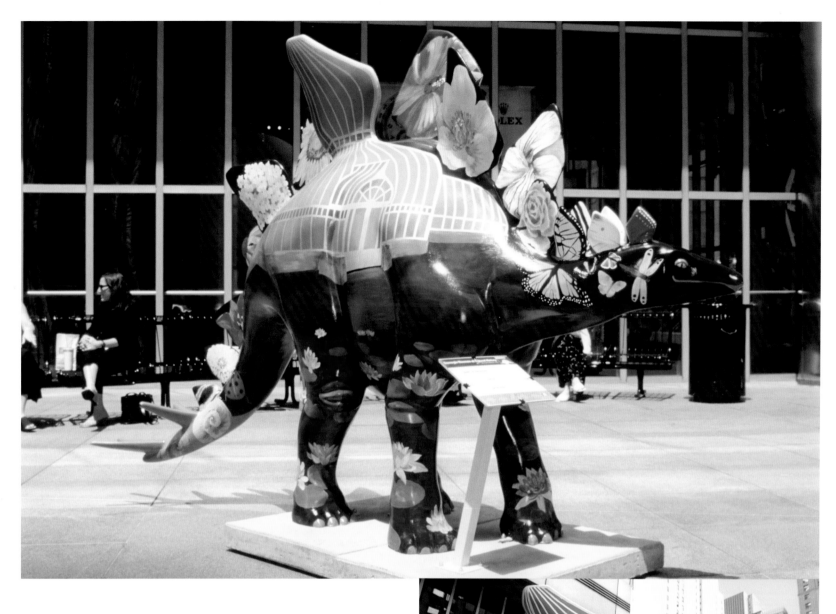

STEGOFLORUS

ARTIST: Glenda Washburn

SPONSAUR: Marcus & Shapira, LLP

Juxtaposed against the urban backdrop, the bold and beautiful flowers covering this dinosaur are a joy to behold. Unlike their more fragile natural counterparts, these flowers will survive season-to-season and year-to-year. The design is based on Pittsburgh's Phipps Conservatory greenhouse and its butterflies and water gardens.

FLORASAURUS

ARTIST: Jennifer Zimmerman and Lauren Urbschat

SPONSAUR: Turner Construction Company

Henry Phipps grew up in poverty in Pittsburgh. He became wealthy beyond his wildest expectations after investing in iron production. This benefactor shared his wealth with the community in a generous way—creating Phipps Conservatory, a glass house where flowers bloom year-round. On this dinosaur, blossoms grow from industrial stacks signifying the germination and fruition of the philanthropic seed planted by Phipps more than 150 years ago.

DINO FACT

Stegosaurus' hind legs are noticeably longer than its forelegs. As a result, the body sloped forward from the hips. This design indicates that *Stegosaurus* probably ate low-lying plants.

TROYUS HILLOSAURUS

ARTIST: **Cynthia Cooley**

SPONSAUR: **Reed, Smith, Shaw & McClay**

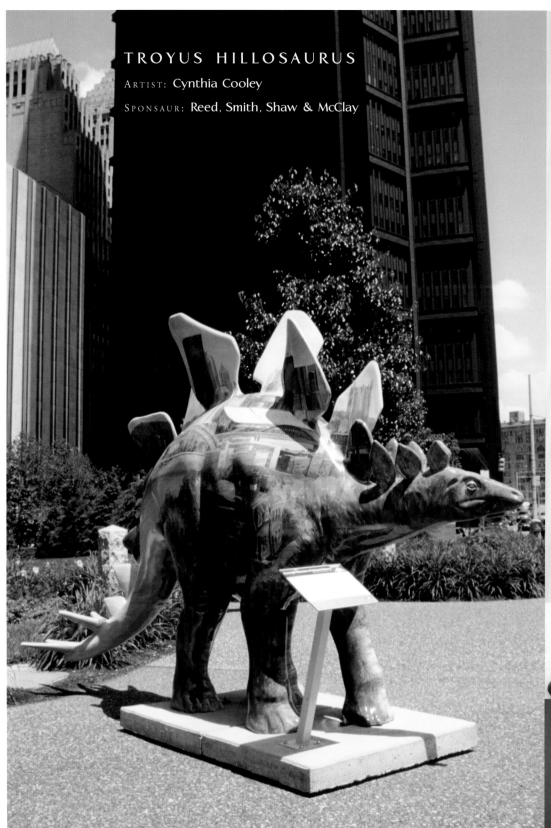

Some workers who built their homes on Troy Hill had jobs in the Herr's Island slaughterhouse and the Lawrenceville steel mills that have gone the way of the dinosaurs. But, like the bones of the dinosaurs, the structures have not disappeared. For this dinosaur, they continue to stand, adding to the lively mix of old and new that makes Pittsburgh so distinctive.

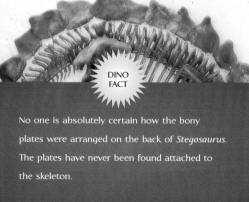

DINO FACT

No one is absolutely certain how the bony plates were arranged on the back of *Stegosaurus*. The plates have never been found attached to the skeleton.

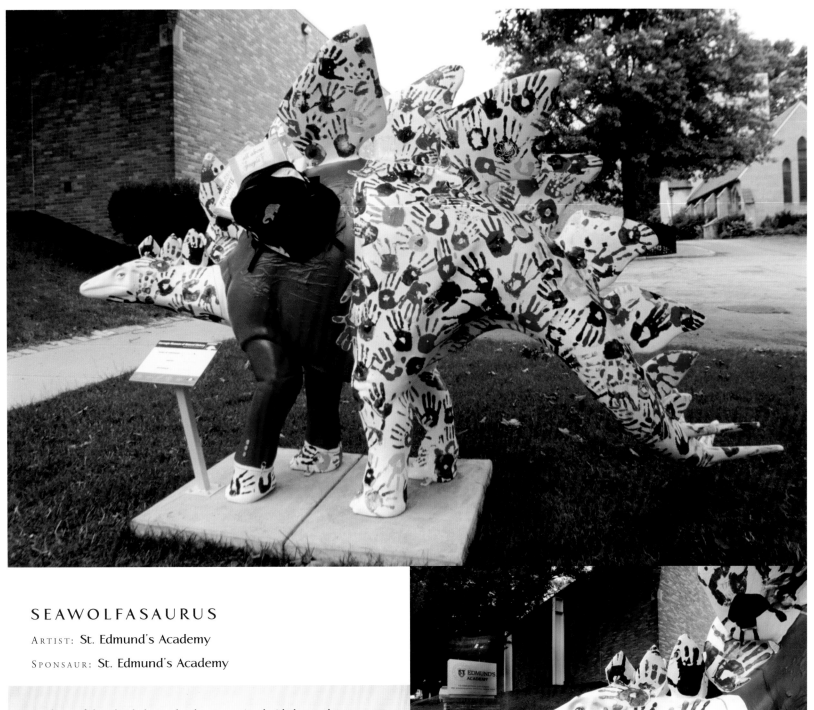

SEAWOLFASAURUS

ARTIST: St. Edmund's Academy

SPONSAUR: St. Edmund's Academy

Students of this closely knit school community decided to make their dinosaur a part of their family by dressing him in the traditional St. Edmund's maroon blazer and a backpack brimming with school supplies. The students left their handprints on the character signifying the impression left on them by the experience.

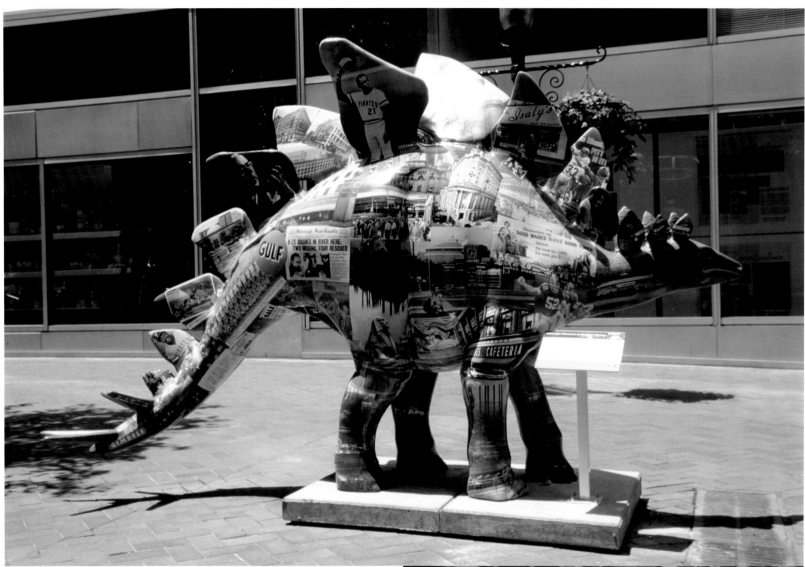

LOST PITTSBURGH

ARTIST: **Shirley Yee**

SPONSAUR: **The Art Institute of Pittsburgh**

Some of Pittsburgh's favorite things are found again on this dinosaur. Covered with photo images of "extinct" Pittsburgh icons, like Forbes Field, Lemon Blennd, Horne's Department Store, and White Swan Park, this creation inspires viewers to recall things warm and dear.

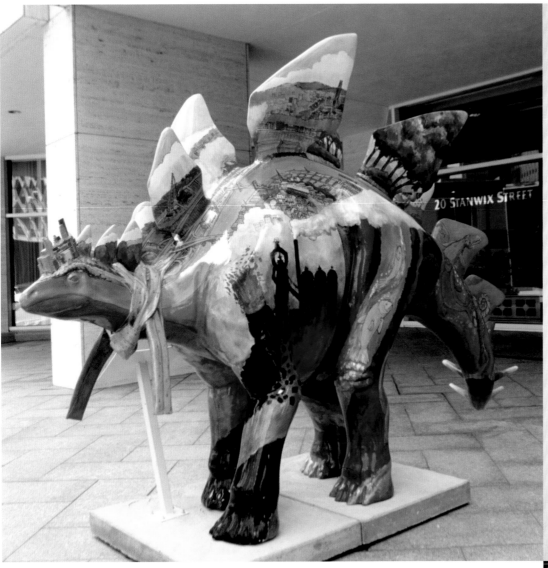

The environmental evolution of Pittsburgh is depicted in the painted and sculpted surface of this design. Scenes include fires of industry being extinguished as the city reinvents itself, a highway choker, a city rising on a hill, and a lush, green forest.

AN ECOLOGICAL HISTORY OF PITTSBURGH

ARTIST: Jonathan Kline, Christine Brill, and Kelly Docter

SPONSAUR: National City

DINO FACT

Stegosaurus weighed 6,800 pounds— about as much as two days' worth of potatoes sold as French fries at Kennywood Park's famed Potato Patch.

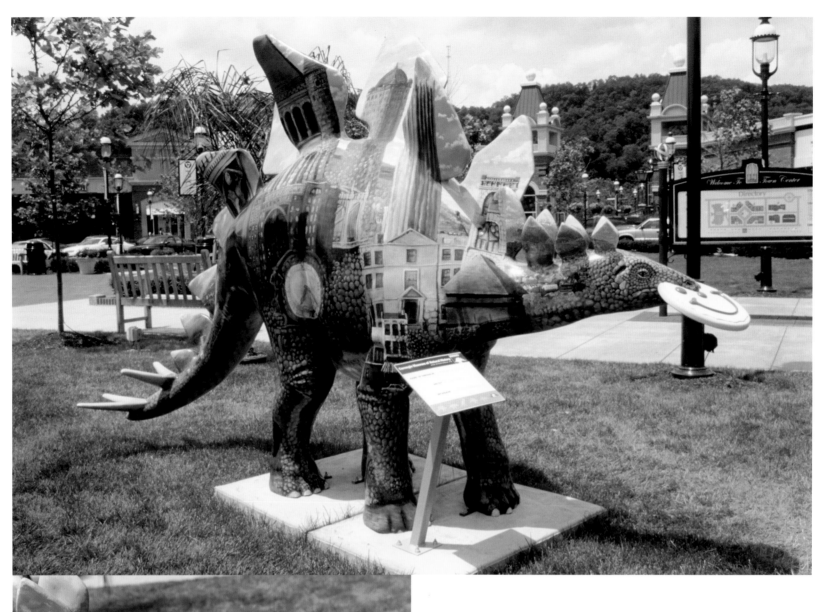

PITTSBURGHIUS ARCHITECTAURUS

ARTIST: **John Alexander**

SPONSAUR: **Eat'n Park Hospitality Group**

Pittsburgh's wide variety of architecture inspired this creature.
Incorporating buildings from the past and present, the right side depicts
architecture that still stands in the city, while the left side illustrates
architecture that has gone the way of the dinosaurs.

PIXELSAURUS

ARTIST: **Quentin Curry**

SPONSAUR: **Babcock Lumber Company**

This dinosaur speaks the lexicon of art through the ages. The pigment mixed with stone dust has its roots in Renaissance fresco painting. The tarcloth and fiberglass are technological developments in building. The lines and pixels form the language of digital imagery. Together these elements of surface and substance form a collage that is "neo-jurassic."

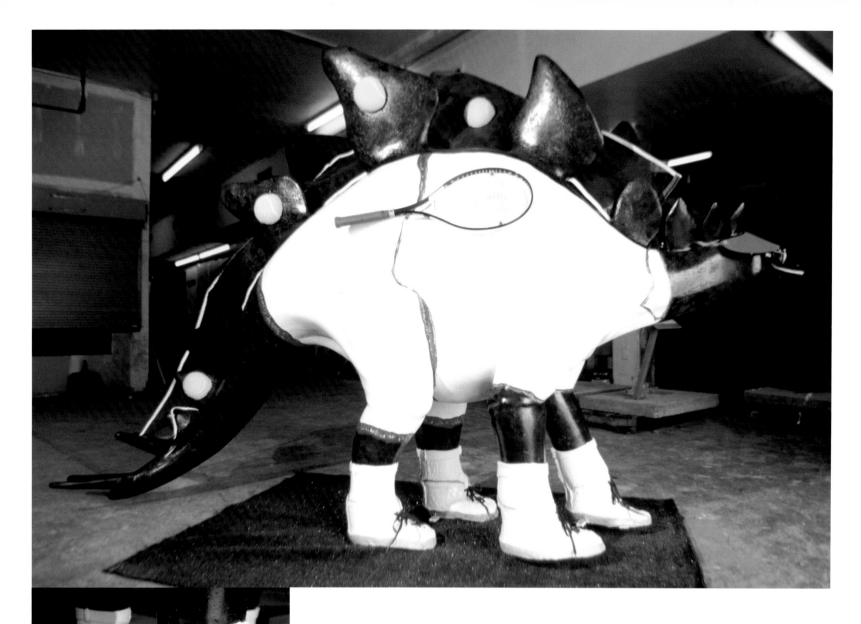

TENNISAURUS

ARTIST: Nellie Lou Slagle and Susie Perelman

SPONSAUR: Carnegie Museum of Natural History

Tennis anyone? This *Stegosaurus* is ready to take the court! Featuring a net, tennis balls, racquet, Har-Tru®, headband, and sunglasses, he is prepared to play. He made his debut at the 2003 US Open sporting dino-sized tennis whites and two pairs of enormous shoes.

A colorful and playful mosaic of Pittsburgh comes to life. On one side, the dinosaur's plates and spikes are peppered with houses just like the city's hillsides. The three rivers are alive with rowers and crossed by bridges, while the Golden Triangle's skyscrapers stand sentinel. On the other side, prehistoric Pittsburgh is depicted speckled with dinosaurs.

SPECTRUM IN THE SHADOWS

ARTIST: **Daviea Davis**

SPONSAUR: **Giant Eagle, Inc.**

DINO FACT

It is assumed that different species of *Stegosaurus* had specific patterns of plates and spines that allowed them to recognize members of their own species.

Torosaurus

With its massive head and sharp horns, *Torosaurus* would have been the bane of any Mesozoic matador. Among the last dinosaurs on Earth, herds of these not-so-little dogies moseyed the American West 65-70 million years ago. This Cretaceous colossus stood seven feet tall at the hip, weighed seven tons, and stretched up to 25 feet long. *Torosaurus'* enormous skull—the largest known of any land animal—measured a staggering 8.5 feet long. This stocky vegetarian had a strong, parrot-like beak and massive battery of teeth that made short work of the greenery of the day, which included low-lying plants such as conifers, cycads, ginkgoes, and some of the world's first flowers. The massive skull was equipped with three long horns, one above its beak and two above its eyes. Most likely, these horns came into play in standoffs against predators or in courtship rivalries. Another distinctive *Torosaurus* feature was the very large bony frill that projected from the back of its head. Perhaps the frill also made the animal look larger and more intimidating to would-be predators. Bands of *Torosaurus* may have formed tight circles to thwart an attack from any carnivore that might have been lurking about.

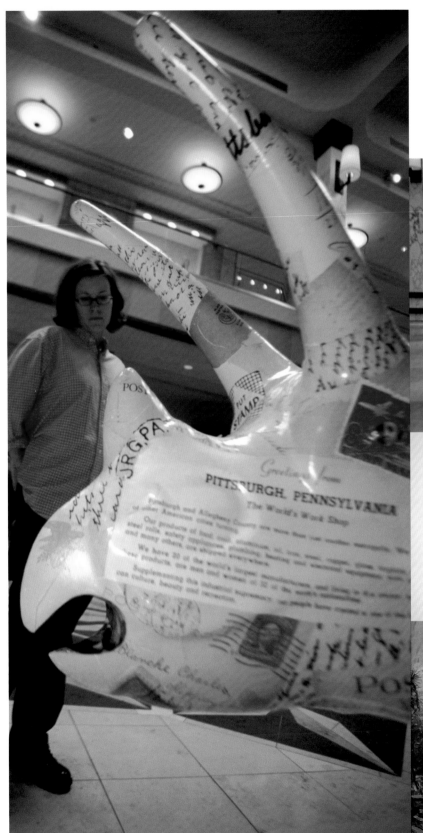

TRAVEL TOROSAURUS

ARTIST: Laura Seldman

SPONSAUR: Monroeville Mall

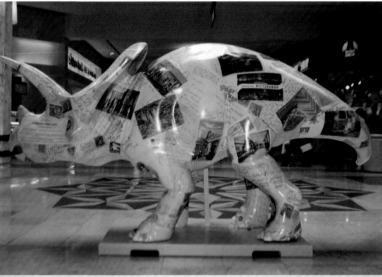

Postcards illuminate the stories and images that connect our past and present. "Travel Torosaurus" is covered with vintage postcards from the artist's personal collection. This photographic quilt celebrates Pittsburgh's culture, science, communities, and communication.

DINO FACT

Torosaurus shared its world with a variety of other animals, including *Triceratops*, *Tyrannosaurus rex*, a variety of duck-billed dinosaurs, armored dinosaurs, and other dinosaurs, as well as birds, pterosaurs, mammals, lizards, snakes, and turtles.

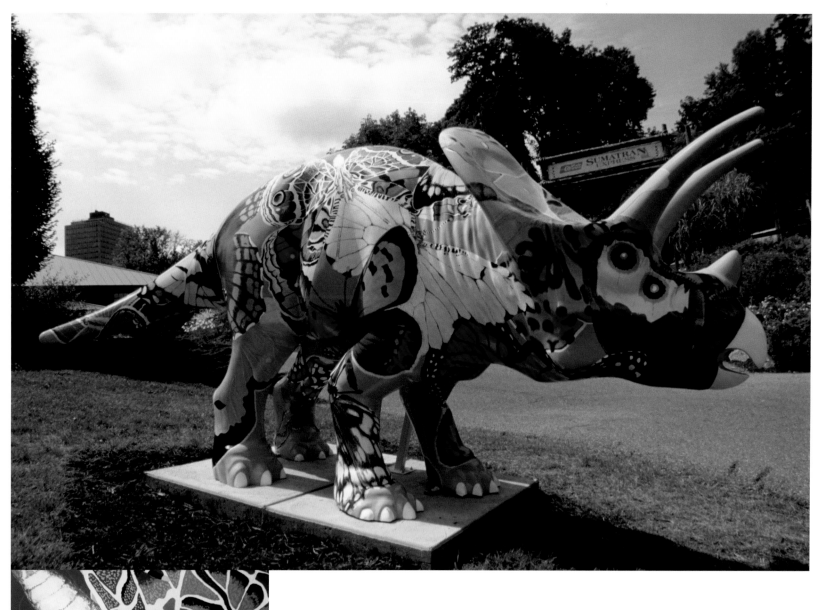

TOROSAURUS LEPIDOPTERON

ARTIST: **Mark Klingler and Cliff McGuire with Students of Oakbridge Academy of Arts**

SPONSAUR: **Oakbridge Academy of Arts**

Just as the dinosaurs have disappeared from the earth, many species are becoming extinct today. Native to Western Pennsylvania, most of the delicate butterflies adorning *"Torosaurus lepidopteron"* are endangered. The beauty of this design reminds us of the incredible diversity in our own backyards and beckons us to protect the natural world.

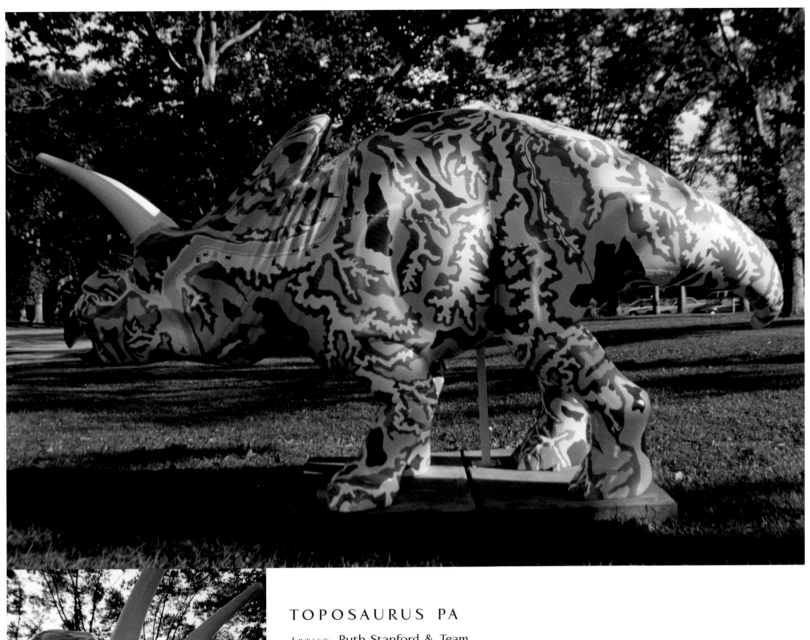

TOPOSAURUS PA

ARTIST: **Ruth Stanford & Team**

SPONSAUR: **J. Preston Levis Charitable Foundation**

"TOPOsaurus PA" combines several unique topographic, historical, and geological features of the Pittsburgh area. Significant landforms, roads, and rivers are placed on the "map" to help indicate the locations of significant fossil deposits and defunct industrial sites.

HOPPER

ARTIST: **Evan Gealy**

SPONSAUR: **Highmark**

This beast of burden pays tribute to Pittsburgh's railroads and their vital role in the steel industry. Coke-laden trains still chug along our tracks on their way to other mills in other cities, reminding us of our glory days as a booming steel town.

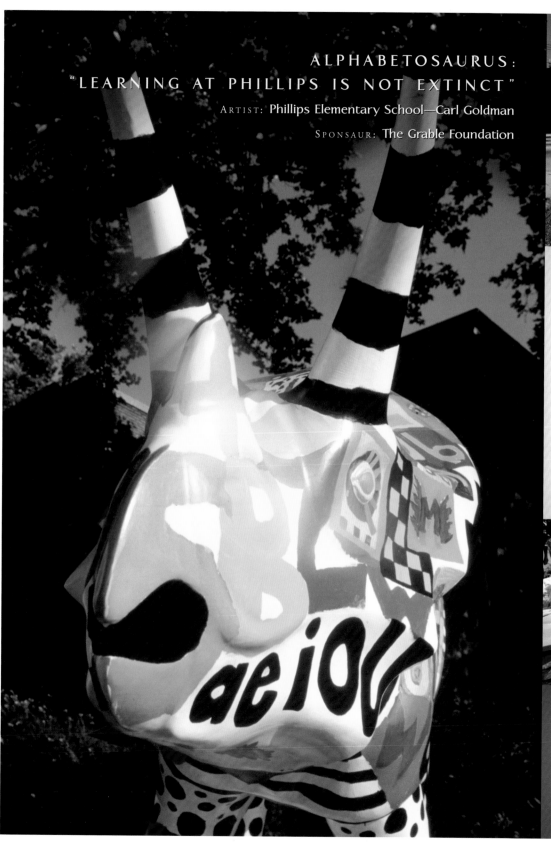

ALPHABETOSAURUS:
"LEARNING AT PHILLIPS IS NOT EXTINCT"

ARTIST: **Phillips Elementary School—Carl Goldman**

SPONSAUR: **The Grable Foundation**

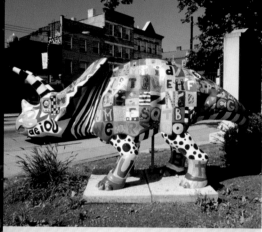

The letters of the alphabet—the building blocks of language and education—inspire the design of Phillips Elementary School's vibrant *Torosaurus*. Under the guidance of art teacher Carl Goldman, students and teachers created the letters and then applied them to the dinosaur.

DINO FACT

Horns are the signature characteristic of one group of ceratopsians, the ceratopsids. Both males and females had horns, although horns did not develop until the dinosaurs were at least halfway grown.

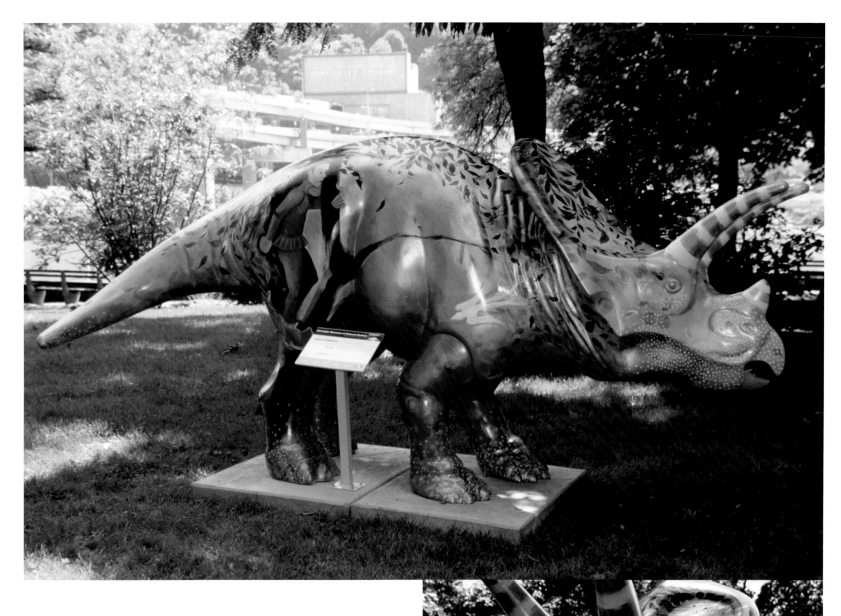

THE BARON IN THE TREE

ARTIST: **Bridget Parris**

SPONSAUR: **Carnegie Museum of Natural History**

This romantic dinosaur celebrates life and love in the natural world. A young swain and his ladylove climb a lush, verdant tree. Birds flit by as the setting sun casts a golden-orange glow to the entire scene.

DINO-MORPHOSIS

ARTIST: **Kent Frazee**

SPONSAUR: **Downtown Athletic Club, Coal Valley Sales
Corporation, and the Spence & Griffin Families**

Life and death contrast and morph in the design of this *Torosaurus*. The
hope created by colorful blooms overcomes the skeletal despair of death
as a dinosaur is pulled back from extinction and given a second chance.

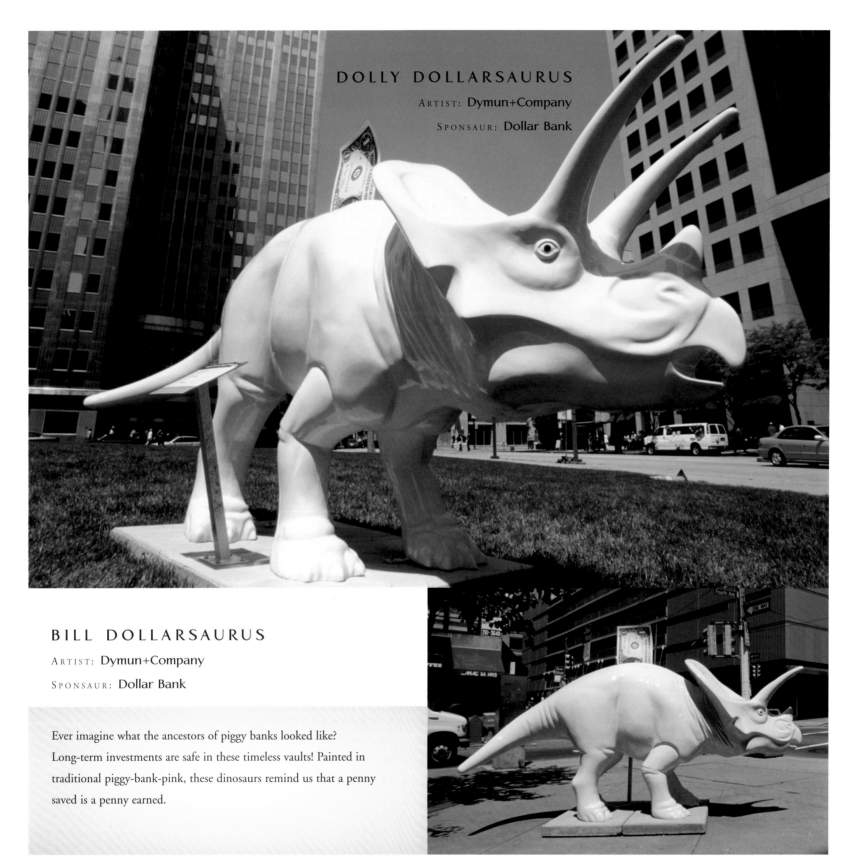

DOLLY DOLLARSAURUS

ARTIST: **Dymun+Company**

SPONSAUR: **Dollar Bank**

BILL DOLLARSAURUS

ARTIST: **Dymun+Company**

SPONSAUR: **Dollar Bank**

Ever imagine what the ancestors of piggy banks looked like? Long-term investments are safe in these timeless vaults! Painted in traditional piggy-bank-pink, these dinosaurs remind us that a penny saved is a penny earned.

TOYOSAURUS

ARTIST: **Renee Dupree**

SPONSAUR: **GENCO Distribution System**

This dinosaur has the look of a child's cluttered closet, stuffed with toys and overflowing with "collectibles." Sporting a coat of many-colored toys, including dice, marbles, game pieces, army men, cars, building blocks, and other trinkets, this playful dinosaur is game for anything!

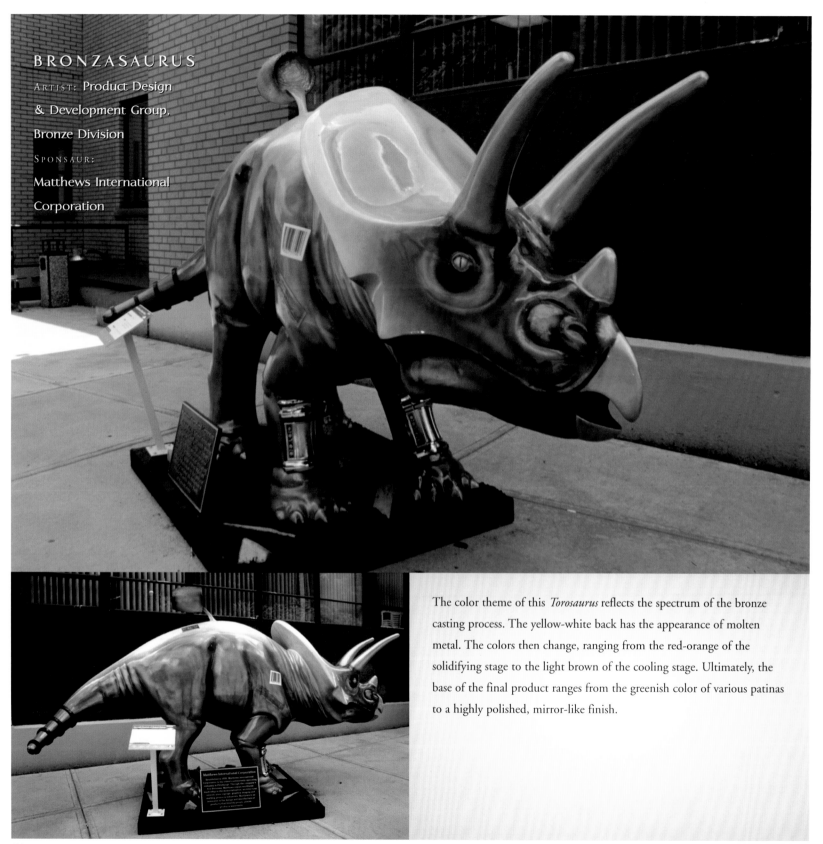

BRONZASAURUS

ARTIST: Product Design
& Development Group,
Bronze Division

SPONSAUR:

Matthews International
Corporation

The color theme of this *Torosaurus* reflects the spectrum of the bronze casting process. The yellow-white back has the appearance of molten metal. The colors then change, ranging from the red-orange of the solidifying stage to the light brown of the cooling stage. Ultimately, the base of the final product ranges from the greenish color of various patinas to a highly polished, mirror-like finish.

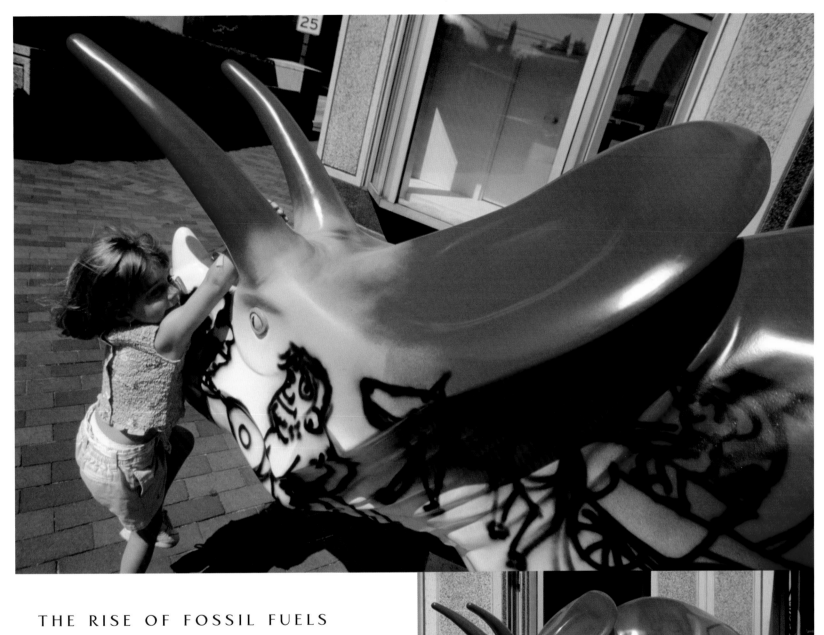

THE RISE OF FOSSIL FUELS

ARTIST: Jamie Matthews

SPONSAUR: Pitt-Ohio Express

From foot to motorcar, the evolution of transportation is depicted on this dinosaur. The design involves a unique painting technique that imitates the optical effect of chrome.

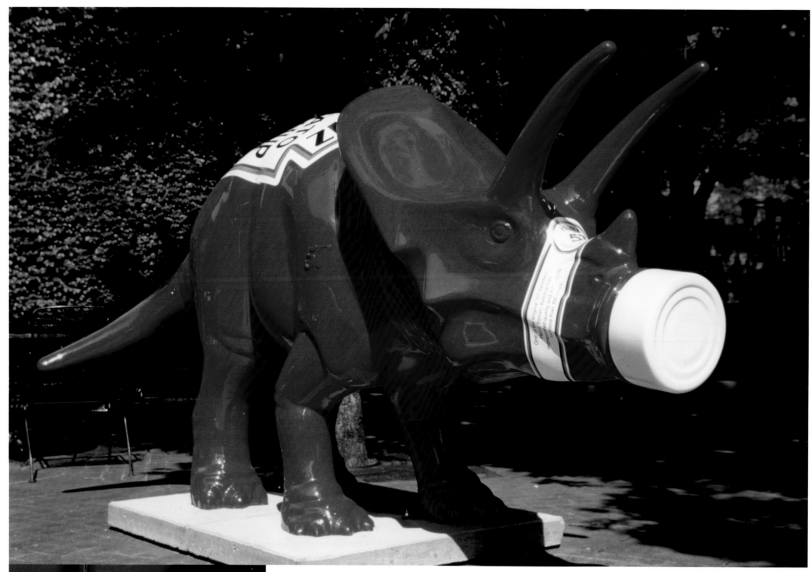

KETCHUPSAURUS

ARTIST: H.J. Heinz Company/Kristina Martinez, BD&E

SPONSAUR: H.J. Heinz Company

Pittsburgh icons Heinz Ketchup and the dinosaur collection of Carnegie Museum of Natural History come together, begging the question: "Would you like to dino-size your fries?"

RENEWALSAUR

ARTIST: Andrew Klein and
Mark Baugh-Sasaki

SPONSAUR: Carnegie Museum
of Natural History

At the dawn of a new century, this dinosaur
is a metaphor for revitalization in the city.
As the era of industry fades, Pittsburgh
progresses into the future, assuming a new
identity.

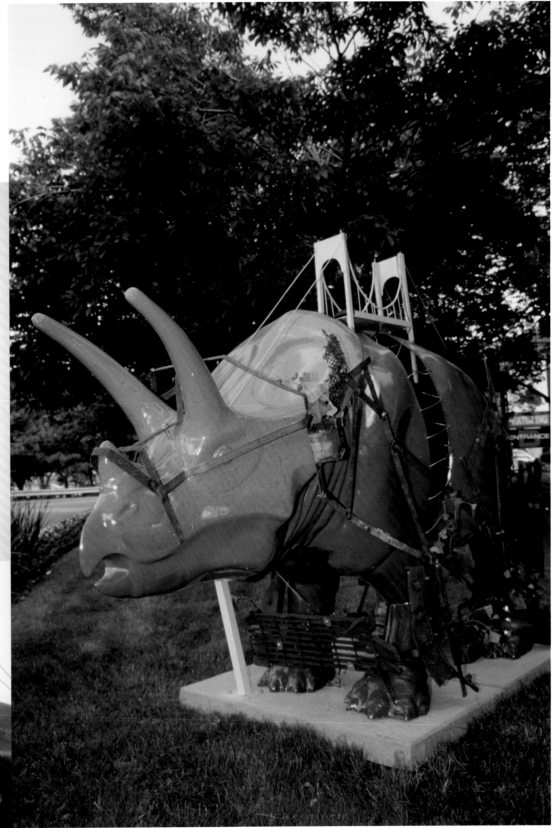

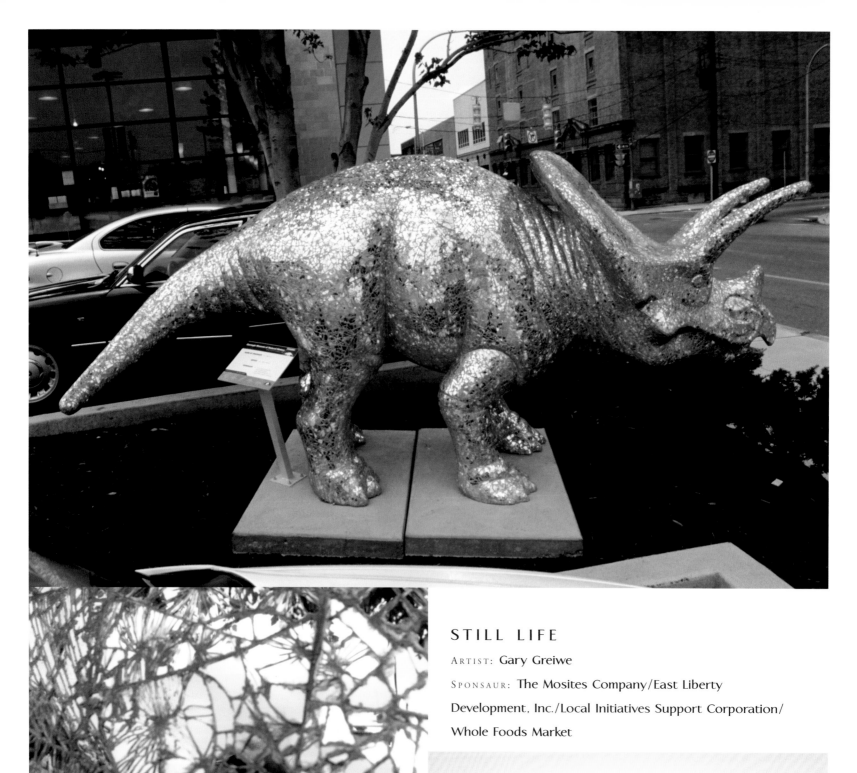

STILL LIFE

ARTIST: **Gary Greiwe**

SPONSAUR: **The Mosites Company/East Liberty Development, Inc./Local Initiatives Support Corporation/ Whole Foods Market**

Thousands of cracked mirrors reflect the world around this *Torosaurus*. As viewers catch a glimpse of their reflections, they are captured within the space of the dinosaur and instantly become a still life themselves.

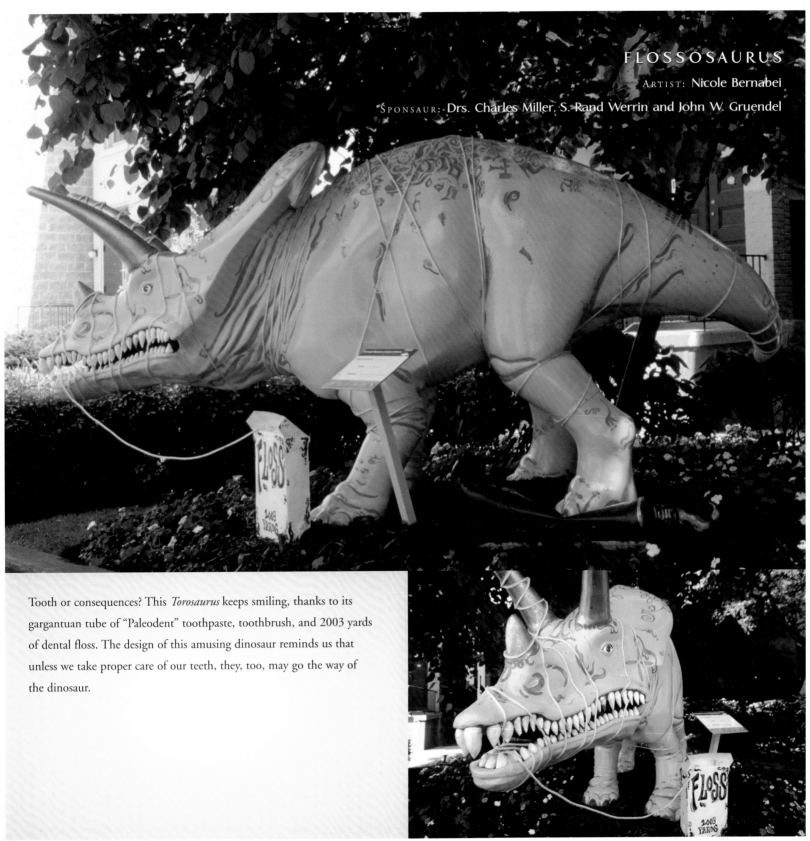

FLOSSOSAURUS

ARTIST: Nicole Bernabei

SPONSOR: Drs. Charles Miller, S. Rand Werrin and John W. Gruendel

Tooth or consequences? This *Torosaurus* keeps smiling, thanks to its gargantuan tube of "Paleodent" toothpaste, toothbrush, and 2003 yards of dental floss. The design of this amusing dinosaur reminds us that unless we take proper care of our teeth, they, too, may go the way of the dinosaur.

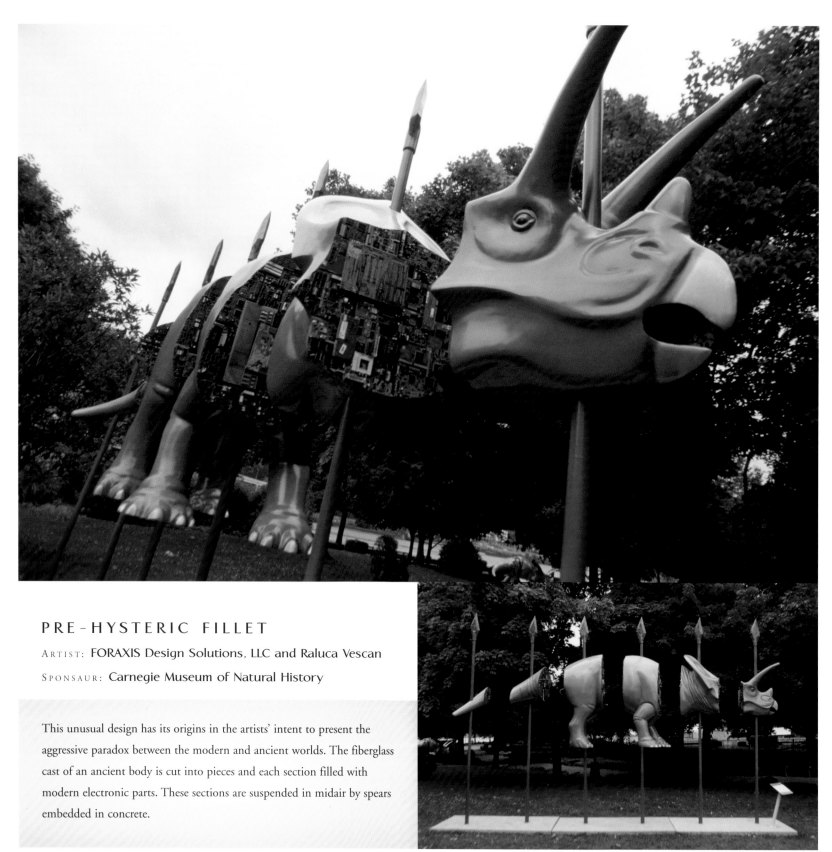

PRE-HYSTERIC FILLET

ARTIST: FORAXIS Design Solutions, LLC and Raluca Vescan

SPONSAUR: Carnegie Museum of Natural History

This unusual design has its origins in the artists' intent to present the aggressive paradox between the modern and ancient worlds. The fiberglass cast of an ancient body is cut into pieces and each section filled with modern electronic parts. These sections are suspended in midair by spears embedded in concrete.

GEORGE WASHASAURUS IN THE FRENCH AND INDIAN WAR

ARTIST: **Barbara Anderson**

SPONSAUR: **Carnegie Museum of Natural History**

This prehistoric patriot, created by a professional costume designer, celebrates Pittsburgh's role in American history. *Torosaurus* is outfitted in the jaunty French and Indian War ensemble sported by future Father of Our Country (and eighteenth century fashion plate) George Washington.

DINO FACT

Torosaurus' name is often misinterpreted to mean "the bull lizard" ("El Toro") in reference to its enormous horned skull. In actuality, the name translates from its Greek origin as "pierced lizard," referring to the holes in the dinosaur's frill.

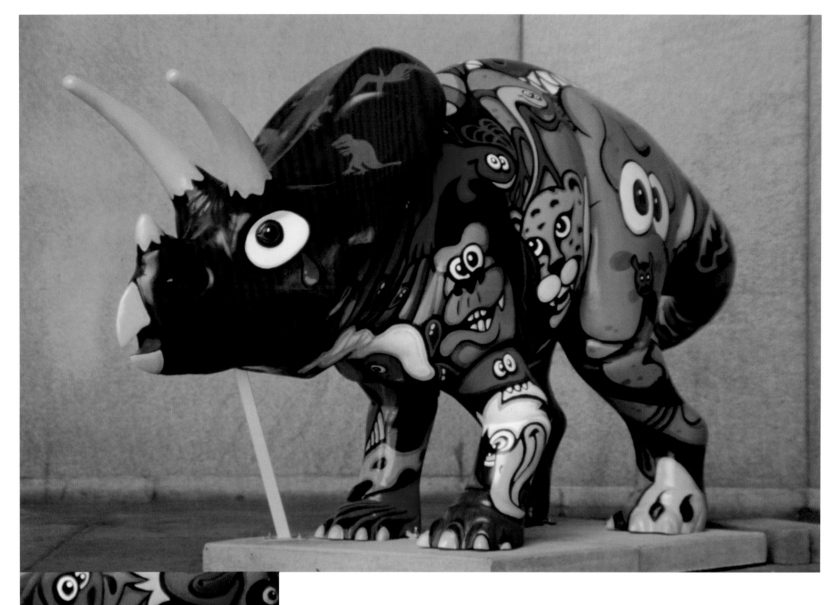

EXTINCTION?

ARTIST: **Raphael Pantalone**

SPONSAUR: **Mascaro Construction Company, L.P.**

The extinct dinosaur is the canvas for a multitude of animal species that are currently threatened with the same fate in the near future. The interlocking design symbolizes how elements of nature are intertwined—when one element is missing, all others are affected. The tear that falls from the eye of the dinosaur mourns the loss of its species, those that have followed it to extinction, and the others headed down its path.

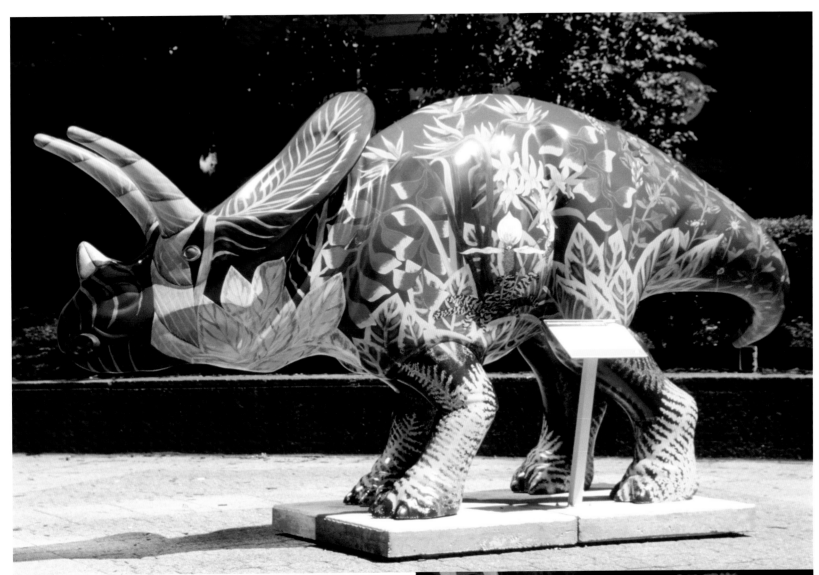

FLORA-TOROSAURUS

ARTIST: Lisa Rasmussen

SPONSAUR: PNC Bank

Lushly decorated with foliage, "Flora-Torosaurus" captures the treasures of Phipps Conservatory and the beauty that can be found in Pittsburgh.

NINO THE CRUSHER

ARTIST: **Rick Bach**

SPONSAUR: **The Art Institute
of Pittsburgh**

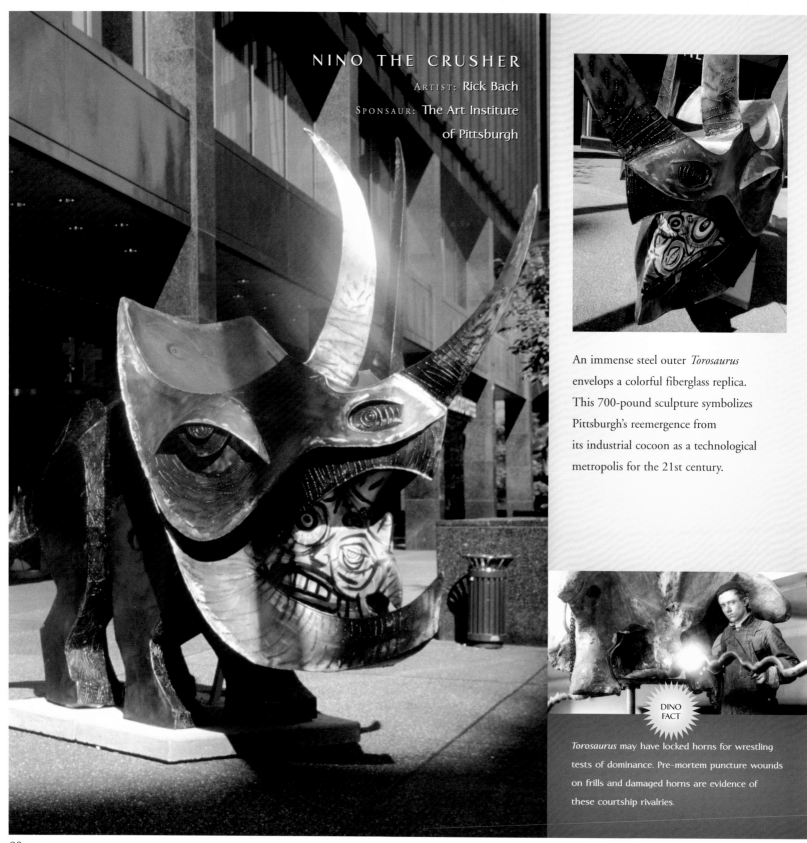

An immense steel outer *Torosaurus*
envelops a colorful fiberglass replica.
This 700-pound sculpture symbolizes
Pittsburgh's reemergence from
its industrial cocoon as a technological
metropolis for the 21st century.

**DINO
FACT**

Torosaurus may have locked horns for wrestling
tests of dominance. Pre-mortem puncture wounds
on frills and damaged horns are evidence of
these courtship rivalries.

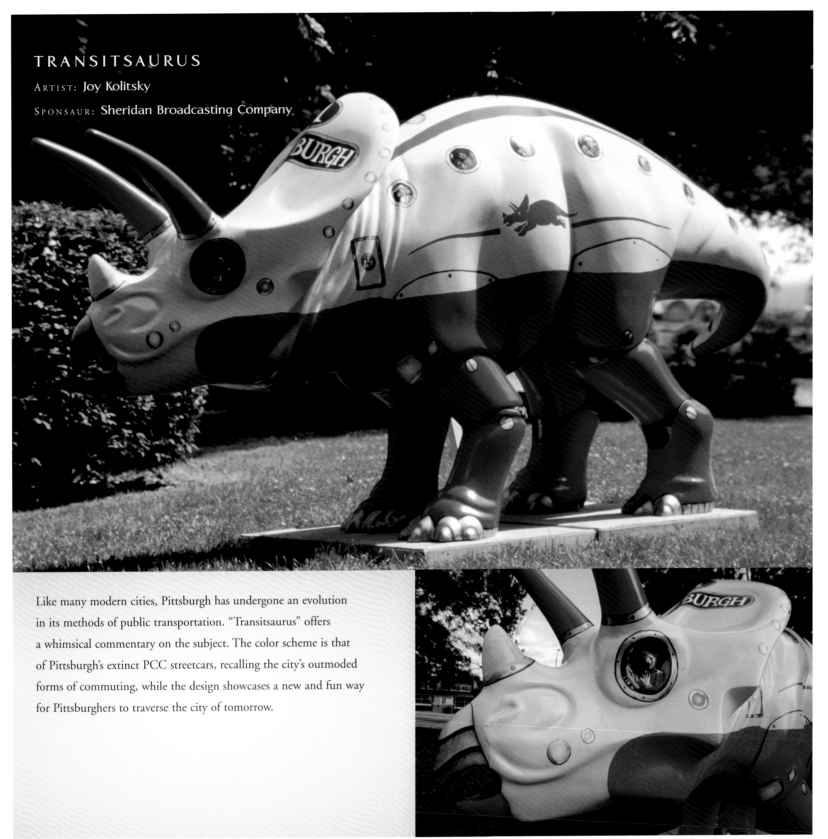

TRANSITSAURUS

ARTIST: **Joy Kolitsky**

SPONSAUR: **Sheridan Broadcasting Company**

Like many modern cities, Pittsburgh has undergone an evolution in its methods of public transportation. "Transitsaurus" offers a whimsical commentary on the subject. The color scheme is that of Pittsburgh's extinct PCC streetcars, recalling the city's outmoded forms of commuting, while the design showcases a new and fun way for Pittsburghers to traverse the city of tomorrow.

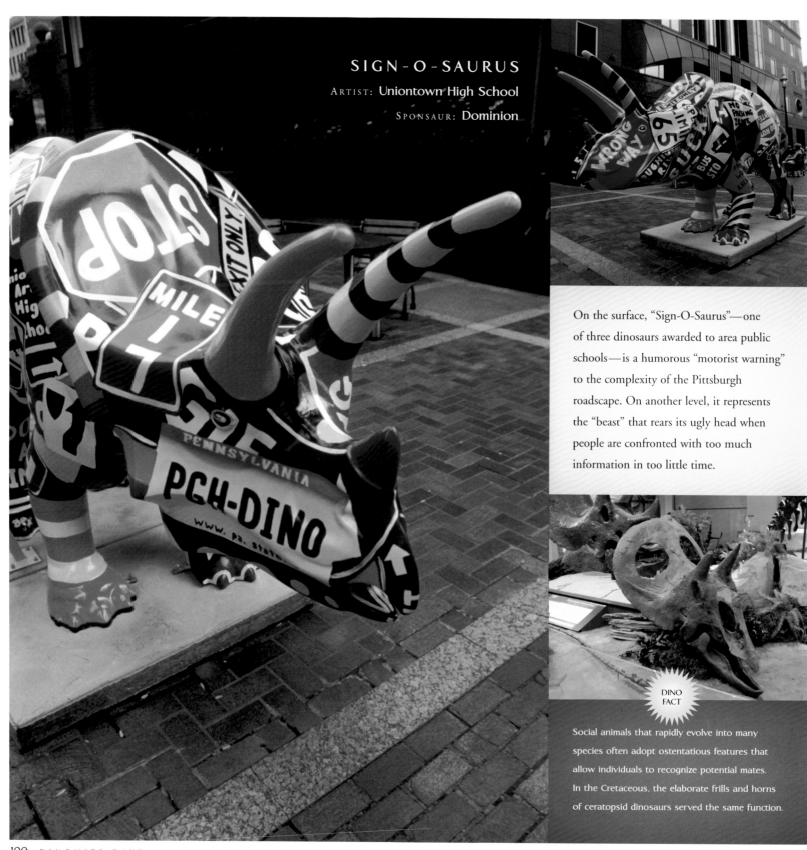

SIGN-O-SAURUS

ARTIST: **Uniontown High School**

SPONSAUR: **Dominion**

On the surface, "Sign-O-Saurus"—one of three dinosaurs awarded to area public schools—is a humorous "motorist warning" to the complexity of the Pittsburgh roadscape. On another level, it represents the "beast" that rears its ugly head when people are confronted with too much information in too little time.

DINO FACT

Social animals that rapidly evolve into many species often adopt ostentatious features that allow individuals to recognize potential mates. In the Cretaceous, the elaborate frills and horns of ceratopsid dinosaurs served the same function.

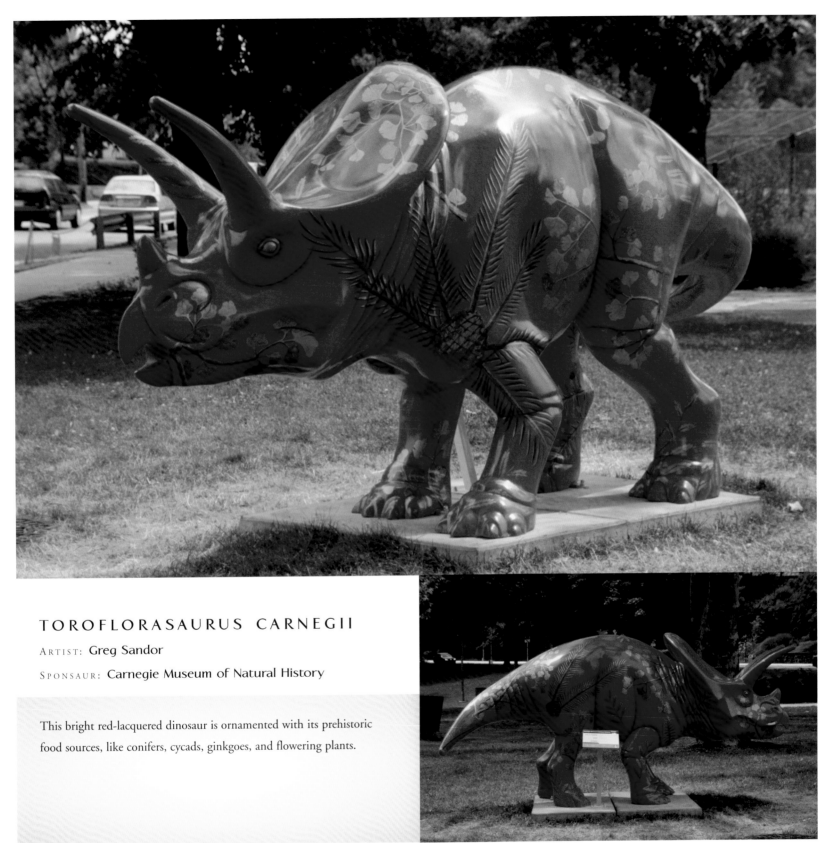

TOROFLORASAURUS CARNEGII

ARTIST: Greg Sandor

SPONSAUR: Carnegie Museum of Natural History

This bright red-lacquered dinosaur is ornamented with its prehistoric food sources, like conifers, cycads, ginkgoes, and flowering plants.

SHADY SIDEOSAURUS

ARTIST: **Shady Side Academy—Scott Aiken**

SPONSOR: **Meyer, Unkovic & Scott LLP**

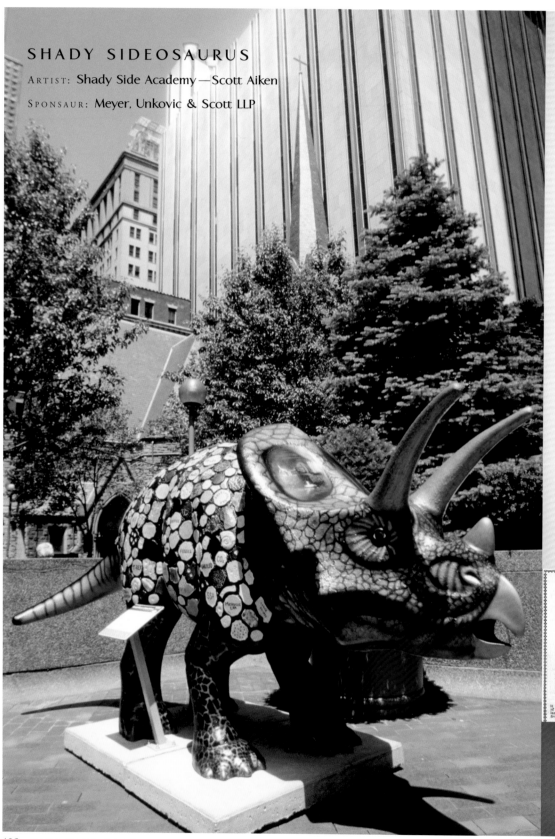

Shady Side Academy's textured *Torosaurus* combines Pittsburgh's traditional black-and-gold color scheme with educational themes. Led by art teacher Scott Aiken, the students created the tiles and fossil replicas that cover the body, including *Phacops rana*, a trilobite that is Pennsylvania's official state fossil.

ANCIENT DWELLER OF THE EARTH

DINO FACT

Torosaurus weighed seven tons—as much as the car that climbs the slopes of the Duquesne Incline.

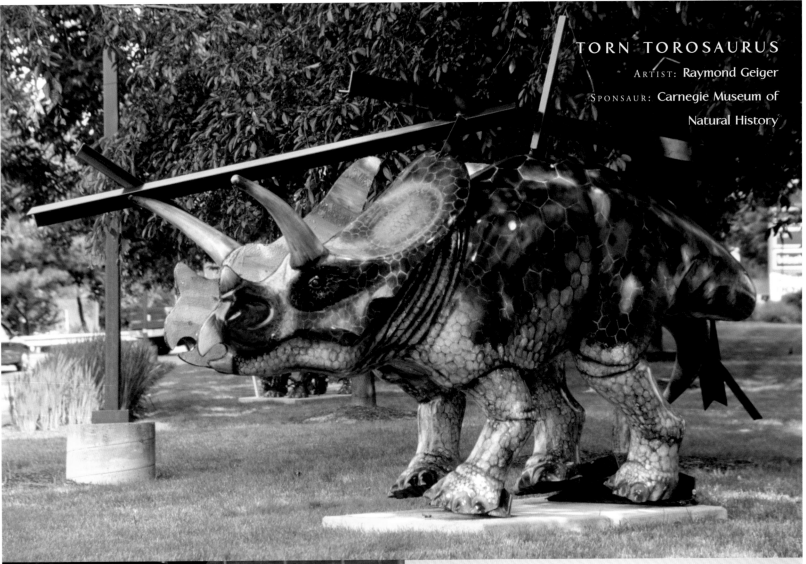

TORN TOROSAURUS

ARTIST: **Raymond Geiger**

SPONSAUR: **Carnegie Museum of Natural History**

Art and architecture come together with natural history in this fractured creature. The dinosaur is divided in half, providing different views of the *Torosaurus* form and commenting on natural symmetry. One half of the interior displays the layering of the geological formations where dinosaur remains are found, while the other demonstrates a conceptualized building of society from earth to sky.

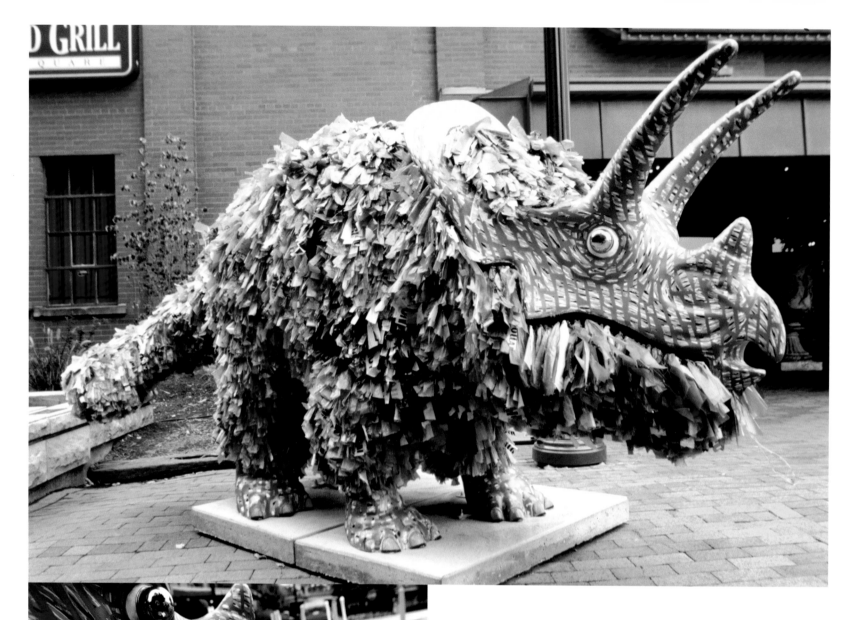

SHAGGY RECYCLESAURUS

ARTIST: JoAnna Commandaros

SPONSAUR: NOVA Chemicals

Pittsburgh's ubiquitous plastic grocery bags give this dinosaur its unique skin. Strips of recycled bags are woven through burlap pelts to create the shaggy effect. With the wind, this animated creature comes to life, undulating in the breeze. This creature is a monumental reminder of our ecological responsibility and the importance of recycling.

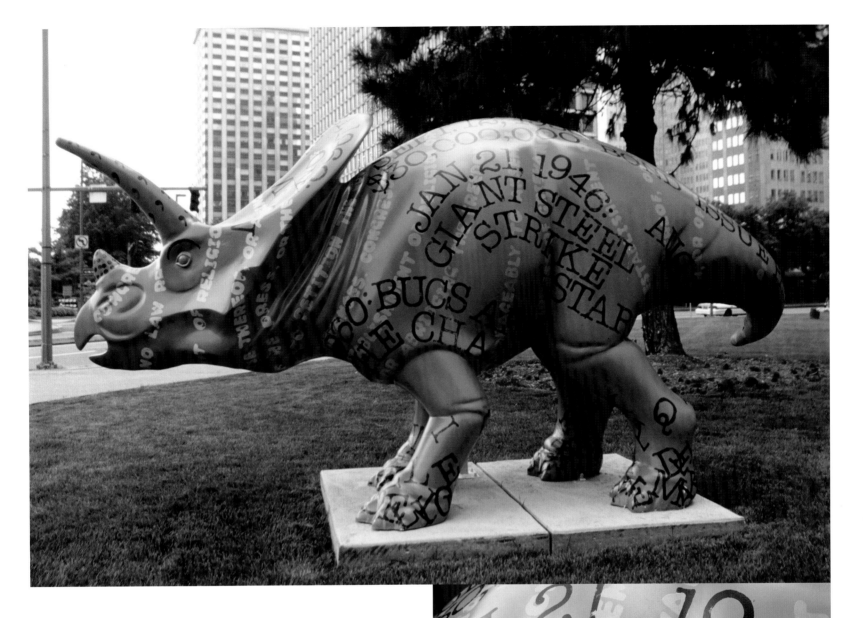

TYPOSAURUS

ARTIST: **Emily Escalante**

SPONSAUR: **Pittsburgh Post-Gazette**

The *Pittsburgh Post-Gazette* covers the events that shape the city's history. This copy-laden creature is emblazoned with actual headlines that chronicle some of Pittsburgh's triumphs and tribulations over more than 200 years. Stamped newspaper font gives character and texture to this old school newshound's *Post-Gazette*-green skin.

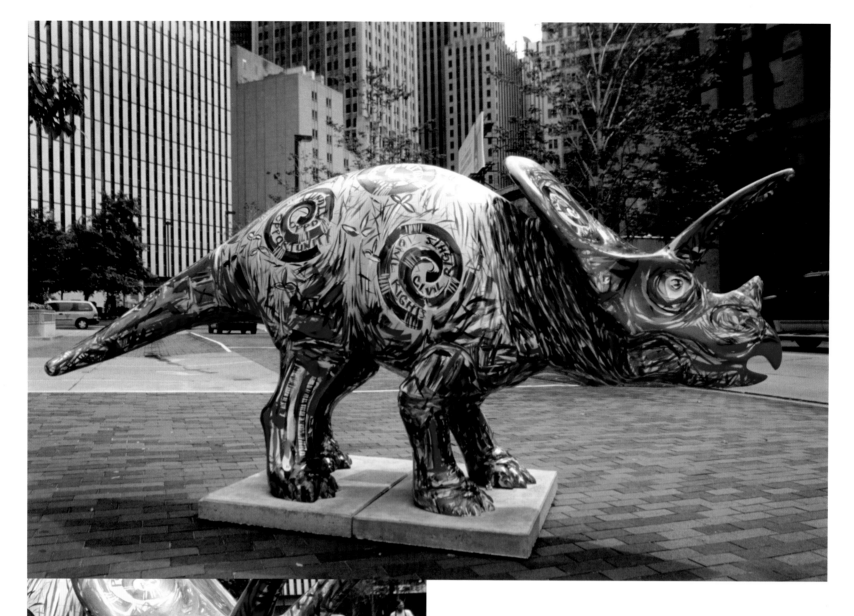

URBAN LEAGUEOSAURUS

ARTIST: **Meredith Young**

SPONSAUR: **Urban League of Pittsburgh and PNC Bank**

A symphony of visual music, "Urban Leagueosaurus" combines electric colors and zesty, abstract brushwork. An African antelope embodies speed and beauty. The words incorporated into the design, including "equality," "opportunity," "self-sufficiency," and "power," reflect the mission of the Urban League.

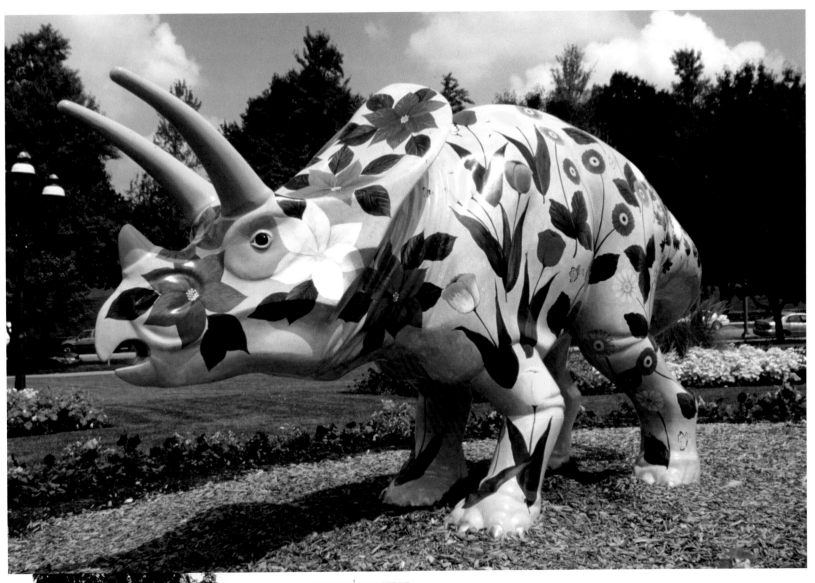

FOUR-SEASON-O-SAURUS

ARTIST: **Elizabeth Keating**

SPONSAUR: **Phipps Conservatory**

The indoor and outdoor gardens of Phipps Conservatory dazzle us with floral wonder—winter, spring, summer, and fall. This dinosaur, abloom with color, celebrates the lively world of flowers.

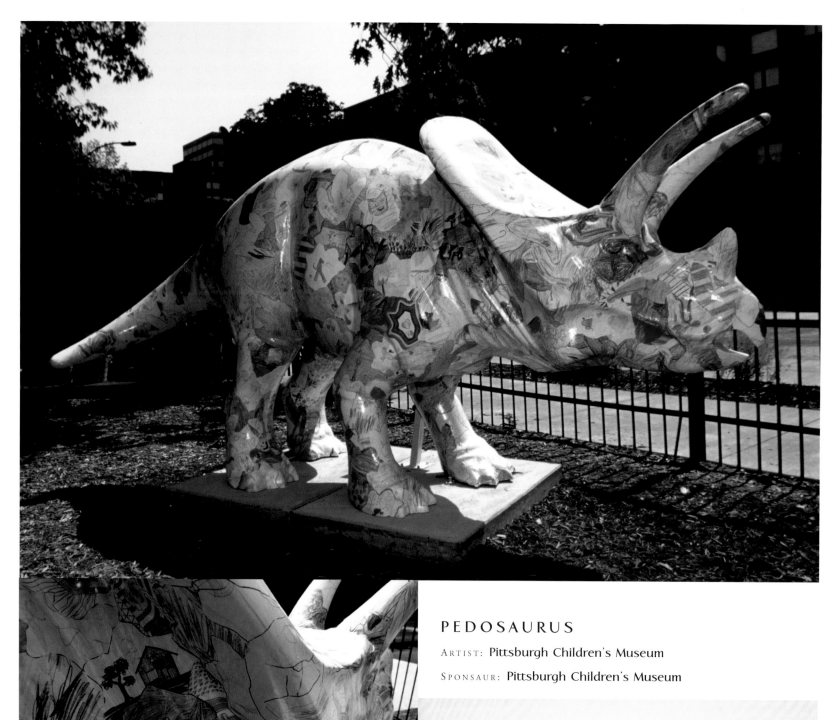

PEDOSAURUS

ARTIST: Pittsburgh Children's Museum

SPONSAUR: Pittsburgh Children's Museum

The Pittsburgh Children's Museum worked with the University of Pittsburgh's Learning Research and Development Center to create this *Torosaurus*. The imaginative design reflects what children between the ages of two and eight think and know about dinosaurs.

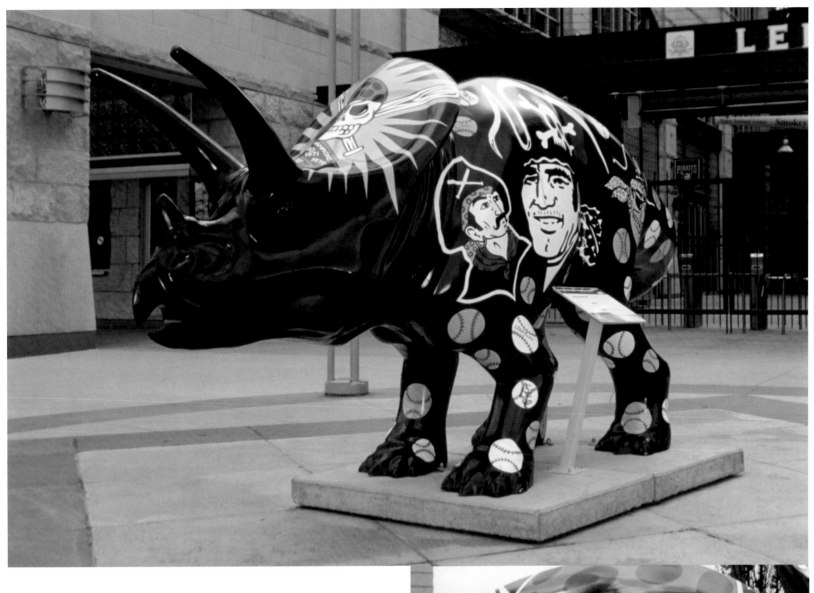

GO BUCS!

ARTIST: **Burton Morris**

SPONSAUR: **Pittsburgh Pirates**

Take me out to the Mesozoic! This baseball behemoth pays tribute to the long history of the Pittsburgh Pirates, tracing the evolution of the team logo from its origins to its modern incarnation.

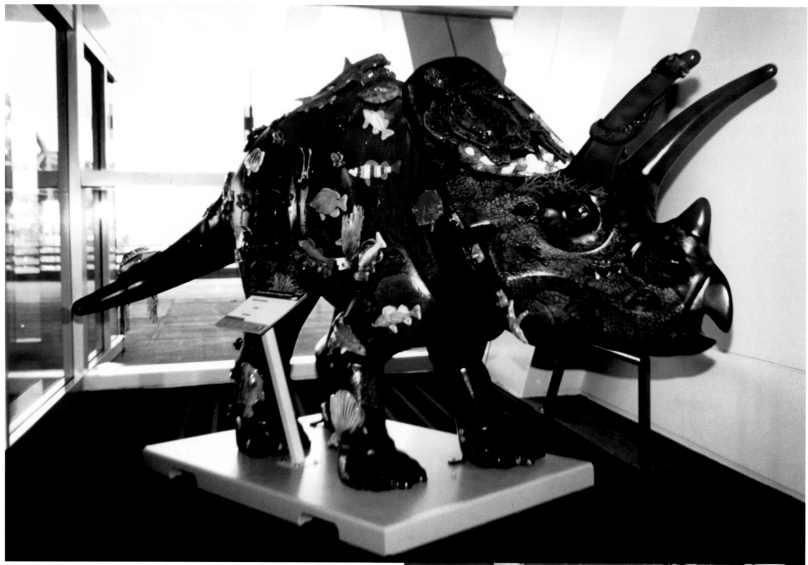

CORAL REEFOSAURUS

ARTIST: Scott Aiken and Dave Evans

SPONSAUR: The Rockwell Foundation

This dinosaur recreates one of the world's most incredibly diverse ecosystems—a living coral reef. An amazing array of sea creatures frolics around the reef, including sponges, sea urchins, parrot fish, angelfish, barracuda, moray eels, stingrays, and sharks. Ceramic tiles shaped like fish and coral dot the dinosaur, creating a three-dimensional effect.

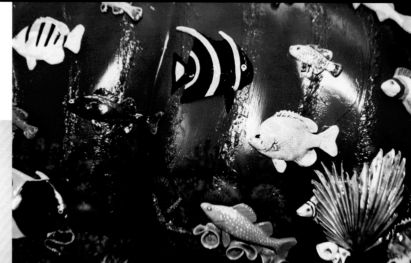

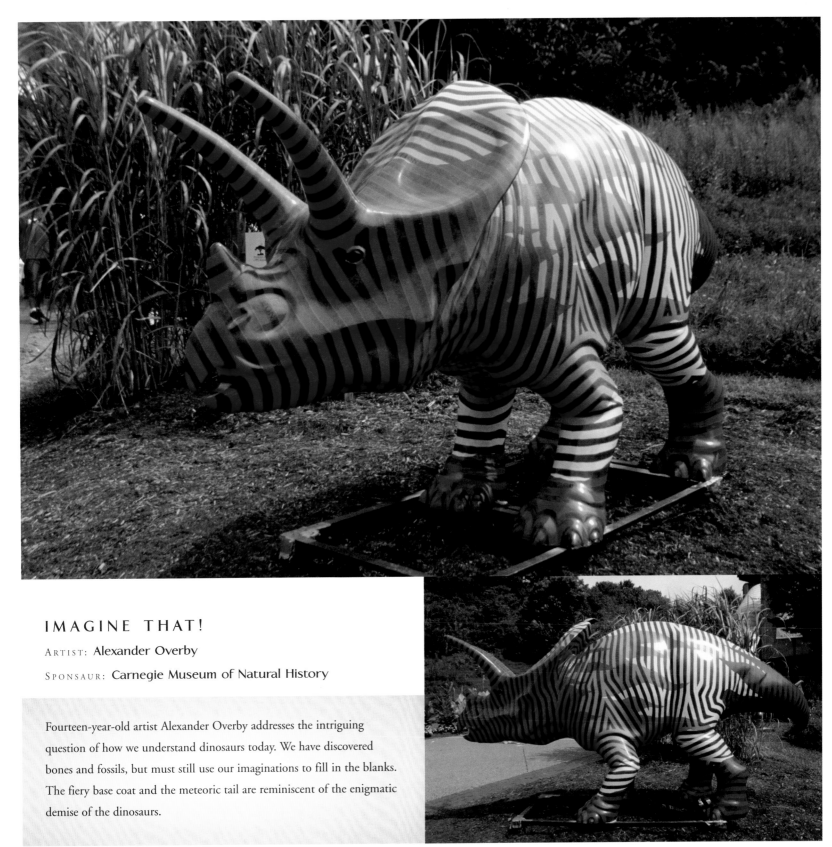

IMAGINE THAT!

ARTIST: **Alexander Overby**

SPONSAUR: **Carnegie Museum of Natural History**

Fourteen-year-old artist Alexander Overby addresses the intriguing question of how we understand dinosaurs today. We have discovered bones and fossils, but must still use our imaginations to fill in the blanks. The fiery base coat and the meteoric tail are reminiscent of the enigmatic demise of the dinosaurs.

"*My family and I have been dinosaur hunting for the last 4 weekends. We would like to thank you for a wonderful time. We have had a lot of fun finding the different dinosaurs and comparing the artists' ideas and designs.*" —DARRELL B.

Field Notes
from DinoMite Days℠ Explorers

"*Thank you for a spectacular summer.*"—DONNA B.

"*Congratulations! You have done a splendid project. We are producing Camel Caravan, our "parade project" for the Middle East over here in Dubai, United Arab Emirates. I have watched your project grow and mature into a beautiful public art event.*" —PATRICIA P., DUBAI, UNITED ARAB EMIRATES

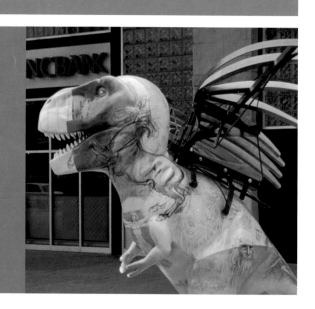

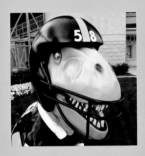

"Just wanted to say how much I enjoyed looking at the dinosaurs...I've been fascinated by the dinosaurs popping up around the area. Thanks for sharing these artists' works with us!" —ZIVA

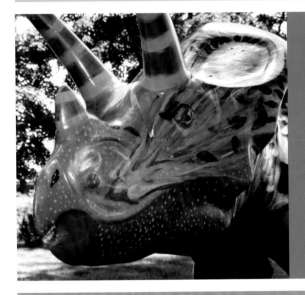

"We were visiting Pittsburgh in August and fell in love with all the dinos. It's hard to say which was our favorite because they all had an aura of their own. Thank you." —GAIL M.

"The dinosaurs of DinoMite Days are terrific. The artists are so imaginative and creative and are to be commended for their work. The dinosaurs are fun, funky pieces of art." —MARCIA H.

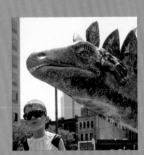

Carnegie Museum of Natural History is grateful to all DinoMite Days℠ sponsors. Many of these supporters share information about their organizations here.

ALCO PARKING CORPORATION is the largest operator of parking facilities in the Pittsburgh area. Grant Oliver Corporation, an Alco affiliate, manages and operates Pittsburgh International Airport parking.

Students at **THE ART INSTITUTE OF PITTSBURGH** learn to apply creative talent, innovation, and skill to a new world of commercial and culinary arts, design, and technology. The campus resides in a historic landmark building in downtown Pittsburgh with 10 floors of fully networked, industry-standard computer labs and specialty facilities. With a history rich in experience and alumni success, the school continues to provide outcome-oriented education leading to the creative careers of tomorrow.

ASTORINO is a full-service company that provides complete architectural services. This Pittsburgh-based firm is one of the fastest-growing architectural and engineering firms in the nation.

BABCOCK LUMBER COMPANY'S roots in Western Pennsylvania date back to 1887. Today, Babcock Lumber Company is still family owned and operates facilities in seven states concentrating on hardwoods and building materials distribution.

With offices in six states and the U.K., **BUCHANAN INGERSOLL** is one of the 100 largest law firms in the nation. Our attorneys are dedicated to building a deep understanding of our clients' businesses

and industries and discovering the best solutions to address their needs.

Recognized as the largest commercial real estate service provider in the tri-state area, **CB RICHARD ELLIS/PITTSBURGH** (CBRE/Pittsburgh) has set the standard for excellence in the marketplace through its predecessor companies for over 50 years.

CITIZENS BANK believes that community involvement and investment are a corporate responsibility and an expression of who they are as a company. Employees are encouraged to get involved with a wide variety of nonprofit organizations, causes, and programs that make a difference in the communities where they live and work.

COMMUNITY CARE PLUS is a multi-specialty medical practice serving the needs of the North Hills community. Its dinosaur is sponsored in memory of Father Francis Solanus Duchala, OFM, who was a longtime patient and friend, for the benefit of the children at St. Sebastian School.

Since 1855, **DOLLAR BANK** has invested billions of dollars in millions of lives and thousands of businesses across the region. In an age of mega-mergers in the banking industry, Dollar Bank has bucked the trend, remaining independent and committed to the people and businesses of southwestern Pennsylvania and northeastern Ohio.

THE DOMINION FOUNDATION supports initiatives and nonprofit organizations that improve the communities in which Dominion, one of the nation's largest

producers of energy, provides energy service and has business interests.

DOWNTOWN ATHLETIC CLUB, COAL VALLEY SALES CORPORATION, AND THE SPENCE AND GRIFFIN FAMILIES are proud to recognize the contribution Carnegie Museums make to our community. Our families, Toran, Alexander, Stephanie, and Bill Spence; Sean, Marian, and Dan Griffin, along with our businesses, salute their efforts!

EAT'N PARK HOSPITALITY GROUP was founded in 1949 as a carhop restaurant. Today, the Pittsburgh-based company has grown to include Eat'n Park Restaurants, a tri-state family restaurant and bakery chain, Park Classic Diners, Parkhurst Dining Services (serving large corporations and colleges and universities), and CURA Hospitality, which provides contract management services to senior living communities.

THE ELLIS SCHOOL is an urban, independent college-preparatory school and the only dedicated to the education of girls and young women in Western Pennsylvania. Each student is inspired to succeed by nurturing her spirit, challenging her intellect and encouraging her vision of the future. In turn, we expect each student to deliver her best, to serve her community and to embrace the diversity of the faculty and student body.

Conveniently located in the heart of the Cultural District, **FIFTH AVENUE PLACE, JENKINS-EMPIRE ASSOCIATES** is a downtown destination with the charm of a quaint European-style arcade. The center is home

to a complementary mix of unique specialty shops, tempting Food Court eateries, and one of the city's premier restaurants, Caffè Amante.

GENCO DISTRIBUTION SYSTEM is a provider of distribution, fulfillment and return center services, and technologies to many of the world's largest retailers and manufacturers. For over one hundred years, GENCO has maintained a tradition of hard work, integrity, reliability, and a deep commitment toward providing its customers with innovative solutions to improve their business while showing them the highest level of customer service they expect and deserve.

GIANT EAGLE, INC. ranked 22nd in *Forbes Magazine's* largest private corporations list and is one of the nation's largest food retailers and distributors. Founded in 1931, Giant Eagle, Inc. has grown to be the number one supermarket retailer in the region with 130 corporate and 84 independently owned and operated stores throughout Western Pennsylvania, Ohio, north central West Virginia, and Maryland. An active community partner, Giant Eagle provides support for local food banks, community events, the United Way, The Salvation Army, Race for the Cure, and other nonprofit organizations.

H.J. HEINZ COMPANY is one of the world's leading producers and marketers of ketchup, condiments, sauces, meals, soups, beans, seafood, snacks, and infant foods. Heinz's 50 companies have number-one or number-two brands in 200 countries, showcased by Heinz® Ketchup, the world's favorite ketchup.

HIGHMARK, a leader in providing quality healthcare coverage throughout Western Pennsylvania, plays an important role in maintaining our community by creating community-based partnerships to improve health, promote healthy lifestyles, and fund programs to build a healthier region.

KETCHUM PITTSBURGH, a leader in public relations and communications consulting, has earned a strong reputation as a full-service agency locally and nationally. Ketchum is known for its passionate, experienced, and highly creative team of professionals who focus on achieving results for a wide array of clients, including Carnegie Museum of Natural History's DinoMite Days.

KOLBRENER, INC. helps organizations adapt and sharpen their brands. Using a proven process, clients have enhanced their brands to reach key audiences and increase revenues while simultaneously realizing cost efficiency in their marketing communications. The Kolbrener team has successfully assisted clients in evolving their brands across a number of markets including consumer goods and services, healthcare, professional and financial services, manufacturing, transportation, technology, telecommunications, and nonprofit.

KOPPERS, INC., headquartered in Pittsburgh, is a global integrated producer of carbon compounds and treated wood products for use by the utility, construction, railroad, aluminum, chemical, and steel industries. Koppers operates 39 facilities in the United States, Europe, Australia, New Zealand, Malaysia, and South Africa.

Founded in 1951 by Cordelia S. May, **THE LAUREL FOUNDATION** supports public arts, theater, history, museums, vocational and adult educational programs, population and environmental issues, and community health programs in southwestern Pennsylvania. In addition to its support of Carnegie Museum of Natural History's DinoMite Days, The Laurel Foundation has been a generous supporter of Powdermill Nature Reserve's Bird-Banding Program and Carnegie Museum of Art .

L.B. FOSTER COMPANY, headquartered in Pittsburgh, PA, is a manufacturer, fabricator, and distributor of rail, construction, and tubular products.

For over 30 years, **MARCUS & SHAPIRA, LLP**, a "mid-size" law firm located in Western Pennsylvania, has provided comprehensive legal services to individuals and businesses. From its founding, the firm has enjoyed an outstanding reputation for providing quality legal services to its clients in virtually all areas of the law.

MASSARO has been providing construction services for three decades. While general contracting makes up the bulk of their business, Massaro also provides development, construction management, and design/build services to clients in the healthcare, industrial, educational, corporate, nonprofit, and government industries. Massaro's vision is to be the best contractor in their class, a model for all their competitors.

MASCARO CONSTRUCTION COMPANY, L.P., a regional general contractor, construction manager, and design/builder whose motto is "Build with the Best," is one of the region's most sought-after providers of construction services. Mascaro is headquartered on Pittsburgh's North Side.

Established in 1850, **MATTHEWS INTERNATIONAL CORPORATION** is the oldest continuously operating company in Pittsburgh. Matthews is an innovator in the design and manufacture of products that identify people, places, products, and events. Through the company's five divisions, Matthews enjoys worldwide leadership in the memorialization, architectural identification, graphics imaging, and marking products industries.

MEDRAD, INC. is a worldwide leading developer of medical imaging devices and services that make it possible to diagnose and treat illness, often without surgery. Heart disease, stroke, cancer, and other diseases are diagnosed faster and more accurately around the world with the help of Medrad technology.

MELLON FINANCIAL SERVICES is a global financial services company. Headquartered in Pittsburgh, Mellon is one of the world's leading providers of financial services for institutions, corporations, and high net worth individuals, providing institutional asset management, mutual funds, private wealth management, asset servicing, human resources services, and treasury services. Mellon's asset management companies include The Dreyfus Corporation and U.K.-based Newton Investment Management Limited.

Since 1943, the attorneys of **MEYER, UNKOVIC & SCOTT LLP** have represented a diverse clientele from large corporations and financial institutions to small venture enterprises and individuals in the areas of corporate transactions, international law and immigration, real estate and construction, intellectual property, employment law, bankruptcy, tax and estate planning, and litigation.

DOCTORS CHARLES MILLER, S. RAND WERRIN, AND JOHN W. GRUENDEL strive to build a relationship with clients which allows a high trust/low fear environment and fulfills clients' overall dental needs for a lifetime, in function, comfort, and beauty.

Located in Monroeville, Pennsylvania, the newly renovated **MONROEVILLE MALL** has 180 retail and specialty stores, including Kaufmann's, Lazarus, JCPenney, Courtyard Café, and the Mr. Rogers' Play Space for Kids.

Founded in 1992, **THE MOSITES COMPANY** is a diversified real estate development and property management firm. Its mission is to create lasting value through well-designed projects with quality building materials and an emphasis on vibrant urban place making through public and private partnership.

NATIONAL CITY offers a full complement of financial services, ranging from investment banking and brokerage services to traditional banking for individuals and businesses. National City is not only committed to providing the highest quality products and services; the bank is also committed to improving the quality of life in the communities it serves.

NOVA CHEMICALS produces polystyrene and polyethylene used in a wide variety of consumer products such as foam cups, insulation, auto parts, electronics, toys, and food packaging. NOVA Chemicals operates in North America and Europe. NOVA strives to be a "Neighbor of Choice" in the communities in which we operate.

OAKBRIDGE ACADEMY OF ARTS is an institution that provides a foundation on which futures are built. Our commercial art and photography programs equip students with the necessary knowledge to contribute to the professional world of graphic communications, photography, and business in today's society.

The **PITTSBURGH POST-GAZETTE** has recorded the story of Pittsburgh since 1786. It has captured its triumphs and tragedies, and has contributed to the very character of the city.

PNC BANK takes a comprehensive approach to helping enrich the lives of its neighbors and drive economic development in the regions it serves. Carnegie Museum of Natural History's DinoMite Days was a great fit for this strategy—it highlighted the museum's outstanding displays, showcased the work of area artists, and attracted visitors to the core of our region. PNC Bank was proud to play a role.

PORT AUTHORITY OF ALLEGHENY COUNTY is committed to Pittsburgh's renaissance. Connecting people to life, Port Authority helps move the city through its evolution into the 21st Century.

Established in 1883, **PPG INDUSTRIES, INC.** is a diversified manufacturer that supplies its products and services around the world. The company makes paint, glass, fiberglass, and chemical products that protect, preserve, beautify, or improve life from home to transportation to workplace.

REED SMITH LLP is a top 20 international law firm dedicated to core values of teamwork, professionalism and mutual respect. The firm has provided an unsurpassed level of personal service throughout its 125-year history, representing some clients since its establishment. At Reed Smith, we believe, "It's not just business. It's personal."

WAMO, a **SHERIDAN BROADCASTING** station, began in Homestead in 1948 as WHOD. In 1956 the call letters were changed to W-A-M-O to represent the Allegheny, Monongahela, and Ohio rivers. In 1974, WAMO-FM and WAMO-AM began separate programming. Today, 106 Jamz WAMO has been broadcasting in Pittsburgh for 55 years, and is the city's number one station for Hip-Hop and R&B.

ST. EDMUND'S ACADEMY is an independent, coeducational school, Pre-kindergarten through grade eight. Educational excellence is achieved through a traditional curriculum augmented by innovative teaching. Students leave St. Edmund's well prepared to encounter the challenges of high school with confidence, as well-adjusted citizens and contributors to the community.

Set at the confluence of the three rivers with breathtaking views of the city skyline, **STATION**

SQUARE, FOREST CITY MANAGEMENT provides Pittsburgh's most unique shopping, dining, and entertainment destination featuring more than 30 restaurants and nightspots like Hard Rock Café. The restored Freight House Shops offer an unparalleled shopping experience.

SURGICAL NEUROMONITORING ASSOCIATES, INC. provides intraoperative neurophysiological testing and monitoring services in most Pittsburgh hospitals and for many of the area's finest surgeons. Focusing primarily on surgeries of the spine and brain, our highly skilled clinical neurophysiologists and technicians are dedicated to assisting surgeons in performing the safest surgery possible.

THE W.P. SNYDER III CHARITABLE FUND provides funding to hospitals, medical research institutions, colleges and universities, and cultural organizations. Since 1950, Snyder family charitable organizations have provided funding to institutions in the Pittsburgh and Western Pennsylvania area.

TURNER CONSTRUCTION COMPANY is a national construction firm that has provided service to the Pittsburgh region since 1908. Turner provides a variety of services including construction management, general contracting, and design-build, and performs a variety of project types including hospital, commercial, education, and interior fit-out.

UNIVERSITY OF PITTSBURGH MEDICAL CENTER (UPMC) is the premier healthcare system in Western Pennsylvania and one of the largest nonprofit healthcare systems in the country. UPMC consistently

places among the nation's top hospitals in *U.S. News & World Report's* honor roll ranking. UPMC has an enormous commitment to Western Pennsylvania, generously donating charitable contributions and uncompensated care to the community each year.

Founded in 1918, the **URBAN LEAGUE OF PITTSBURGH** is the largest comprehensive social service/civil rights organization within Allegheny County. For 85 years, the Urban League of Pittsburgh has provided valuable services while improving the quality of life of Pittsburgh and Allegheny County residents. The mission of the Urban League of Pittsburgh is to enable African Americans to secure economic self-reliance, parity, power, and civil rights.

WHOLE FOODS MARKET, the world's largest natural and organic foods supermarket, was founded in 1980 in Austin, Texas. The motto, "Whole Foods, Whole People, Whole Planet" captures the company's mission to find success in customer satisfaction and wellness, employee excellence and happiness, enhanced shareholder value, community support, and environmental improvement.

WINCHESTER THURSTON, a college preparatory, coeducational K-12 independent school, operates two campuses—an urban city campus in Shadyside and a rural seven-acre North Hills Campus. Through its rigorous and engaging program, WT encourages students to develop independent thinking, a lifelong love of learning, and a commitment to community service. The school is home to an award-winning visual arts program.

INDEX BY SPONSAUR